IMAGES
of America

CINCINNATI
Revealed

A PHOTOGRAPHIC HERITAGE OF THE QUEEN CITY

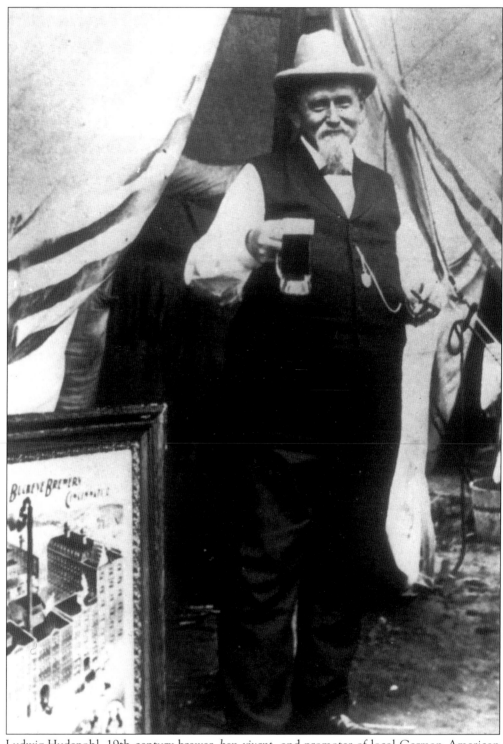

Ludwig Hudepohl, 19th-century brewer, *bon vivant,* and promoter of local German-American culture. In addition to his skills in making beer, Hudepohl also was very active in forming local ethnic singing societies and mutual aid organizations.

CINCINNATI

Revealed

A PHOTOGRAPHIC HERITAGE OF THE QUEEN CITY

Kevin Grace and Tom White

ARCADIA
PUBLISHING

Copyright © 2002 by Kevin Grace and Tom White.
ISBN 978-0-7385-1955-5

Published by Arcadia Publishing
Charleston, South Carolina

Printed in the United States of America

Library of Congress Catalog Card Number: 2002101547

For all general information contact Arcadia Publishing at:
Telephone 843-853-2070
Fax 843-853-0044
E-mail sales@arcadiapublishing.com
For customer service and orders:
Toll-Free 1-888-313-2665

Visit us on the Internet at www.arcadiapublishing.com

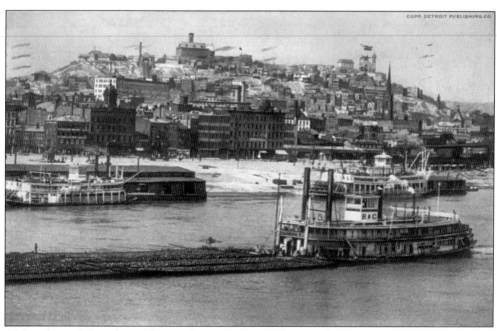

Although much has changed since this image was made around 1910, a towboat pushing barges of coal is as common a sight today as it was then. Here, a steam-powered sternwheeler makes its way downstream past Cincinnati's public landing.

CONTENTS

ACKNOWLEDGMENTS

We would like to thank our colleagues at the University of Cincinnati with their keen eyes for images: Greg Hand and Jay Yocis; and in the Archives and Rare Books Department Don Tolzmann, Alice Cornell, and Anna Truman.

Thank you to Mary Anna DuSablon for walking all the steps of Cincinnati and discovering their place in the city's history; and to Dan Hurley, who works so hard to make a seamless pattern between past and present. Also, thanks to the late civic activist and photographer Danny Ransohoff, who was always encouraging and enthusiastic in any discussion about documenting the city.

Appreciation goes to Laura Chace and the staff of the Cincinnati Historical Society for their research assistance over the years, and to postcard enthusiasts Don Skillman, Mary Mecklenborg, and Sue Claybaugh.

Thanks to everyone we've bumped into over the past quarter century who had a story to tell, and to all the fine Cincinnati chroniclers who preceded us.

And, especially, thanks to my wife, Joan Fenton, and our assorted Graces: Josh, Sean, Courtney, Bonnie, and Lily; and to Joan's grandfather, the late journalist and Terrace Park historian, Ellis Rawnsley. I appreciate all his stories over the years.

KG

Heartfelt thanks to my wife, Michelle, and our daughter Anna, for their patience and support; to my mother and father, Jean and Tom White, for a lifetime of love and encouragement; and to my late uncle, Owen White, whose dedication to lifelong learning continues to provide inspiration. Without their caring and influence this modest achievement would not have been possible.

TW

INTRODUCTION

Cincinnati is a river town. Or, at least it is in the perception of most people who know it. But Cincinnati is also a city of hills and extended bottomland along the Ohio River. It is a southern city, a northern city, and a midwestern city—depending on one's approach to geography, history, trade, and cultural heritage. It is a thriving metropolis often caught in the throes of trying to redevelop itself, a city that experiences racial problems and genuinely tries to remedy them, a hometown of culture and conservatism, of innovation, bad weather, spectacular architecture, sports that are by turns woeful and exhilarating, and its own distinctive festivals and food. In short, Cincinnati, Ohio, is a modern American city.

A favorite description of Cincinnati's early frontier days is provided by the 1792 impression of Johann Heckewelder, a German traveler:

> It is overrun with merchants and traders. Idlers are plentiful here, and according to the assertion of respectable people, are a multitude like the Sodomites. Although this town, according to description, is chiefly filled with bad people, yet it keeps a minister.

Heckewelder's opinion perfectly carries the fact of Cincinnati's beginnings: it was a brawling pioneer town on the westernmost edge of the country. The Ohio River gave the town a purposeful location, and it grew from there. Because of its location in the frontier of the Northwest Territory and its subsequent development, Cincinnati attracted a variety of new citizens of every racial, ethnic, and religious persuasion. And this variety is what has made the Cincinnati of today. From its incorporation in 1788, and its place as a major city in the new state of Ohio in 1803, Cincinnati drew together the 19th-century likes of industrialist Miles Greenwood, book publisher Robert Clarke, educator William Holmes McGuffey, music conductor and impresario Theodore Thomas, keen medical doctor Daniel Drake, and manufacturers William Procter and James Gamble. It was this broadness of types that made a rich history out of good and bad, mistakes and successes, men and women, churchgoers and saloon denizens. Cincinnati has been a city with a river highway, a "Porkopolis" of pigs driven to market, a railroad town carrying its products south and west, a 20th-century city of interstates and airports, and now a 21st-century metropolis of internet and communications. It's great stuff.

So how does one tell Cincinnati's story in pictures now that it is in its third century? Of course, it's been done many times and remarkably well by several writers, so this book has to

be a little bit different. The tale of the "Queen City" has to be told in an accessible way, in a manner that is at once familiar and revealing.

In the pages of photographs that follow, the earliest dates from the age of ambrotypes before the Civil War and the last from just a generation ago. A great many of the images are from vintage postcards, especially dating from the national mania of producing and collecting these cards from 1900 to World War II. It is in these pictures that one can see the pride of place in Cincinnati, the buildings that have changed or disappeared, and the sense of a coherent city. The other images are perhaps a little more documentary in nature, as they provide a visual catalog of events and people.

The chapters serve to outline this approach. "Cityscape" provides a cogent look at downtown, at its evolution in size and style. It is in downtown that one sees the familiar landmarks: Fountain Square, Findlay Market, the shops and stores. Chapter Two, "Taking Care of Business," examines the development of commerce in Cincinnati, something that has always been hotly debated: Is this what we are about as a community? How does business contribute to the quality of life? The next chapter, "Getting From Here to There," visually explores how Cincinnatians have built the river into local life, how political and planning folly attempted a subway system, how transportation has encompassed trolleys and inclines, railroads and highways.

"Neighborhoods" looks at the core of life in Cincinnati, the definition of place. "Benefactors and Scalawags" is, it is hoped, an honest look at not only those citizens who have worked to improve and enrich life, but those people whose colorful characters have added drama and embarrassment, and, maybe, a little fun as well. After all, those who serve time also enrich our lives. Chapter Six, "The Sporting Life," portrays a major part of Cincinnati. Sports have always been important to the quality of life here, and they have given Cincinnatians equal moments of cheers and boos, and appreciation of the strength of the human spirit.

"Leisurely Times" shows Cincinnatians enjoying themselves in parks and zoos. Not all of this history is sweetness and light: Coney Island was segregated until the 1950s, and Cincinnatians of every race should know that fact. In the city's history, race relations are volatile and are still a focus for improvement. Not every one has—or has yet—been given access to all that is Cincinnati. "Mind, Body, and Spirit" looks at how Cincinnatians have been educated, how souls have been soothed, how bodies have been healed, and in the case of the Spring Grove image, how they have been laid to rest. Finally, in "Music and Arts," we explore another aspect of spirit in Cincinnati, how we have welcomed the muses. But this chapter shows more than singing and pictures and theater. This last chapter exemplifies how Cincinnatians have gone beyond the everyday lives they lead to explore the possibilities they have, and have appreciated.

We hope readers find these images are a good mix of the familiar and the seldom, if ever, seen. Perhaps there will be discovered a nugget of new information, or a moment of marvel at what an image reveals. There are thousands of words inherent in these pictures and we invite everyone to read them all. And, don't worry about spilling a little of Cincinnati's famous chili on the book while you read. We'll understand.

<div align="right">Kevin Grace and Tom White</div>

One

THE CITYSCAPE

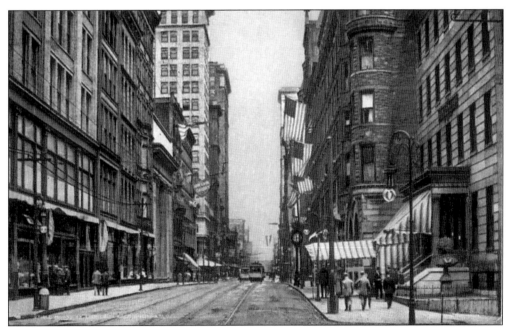

Fashionable Fourth Street is shown in this 1908 postcard. The street was the city's financial center and home to posh department stores, specialty shops, and hotels. With galleries springing up at the western end of Fourth, it is now notable not only for its lawyers and bankers, but artists and photographers as well.

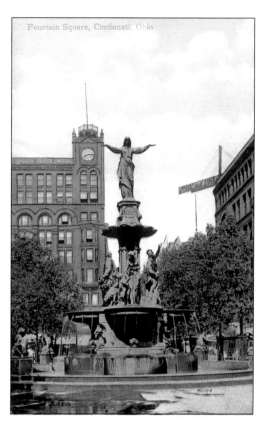

Given to the city in 1871 by Henry Probasco in memory of his late brother-in-law and business partner, the Tyler Davidson Fountain was designed as an object of function as well as beauty. Water fed to the four drinking fountains positioned around the perimeter was run through yards of copper tubing installed in a subterranean chamber. During the summer months this chamber was packed with ice, providing a continuous flow of chilled water to thirsty citizens.

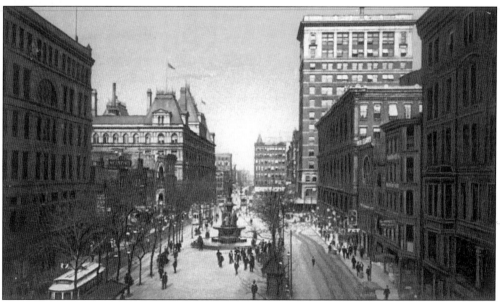

For nearly a century, the Tyler Davidson Fountain stood on a 60-foot by 400-foot esplanade in the middle of Fifth Street between Vine and Walnut. Rededicated and moved to its present position in 1971, it continues to be Cincinnati's most recognizable symbol.

Designed by Samuel Hannaford, Cincinnati's City Hall at 801 Plum Street is a massive Romanesque structure that occupies an entire city block. A bold and powerful building, City Hall was dedicated on May 13, 1893. Hannaford included numerous stained glass windows depicting Ohio scenes, and made other windows smaller at each ascending level to achieve the illusion of additional height.

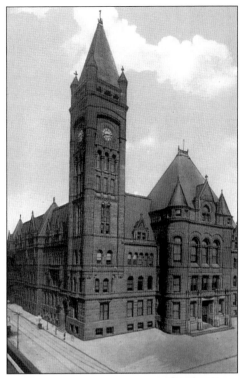

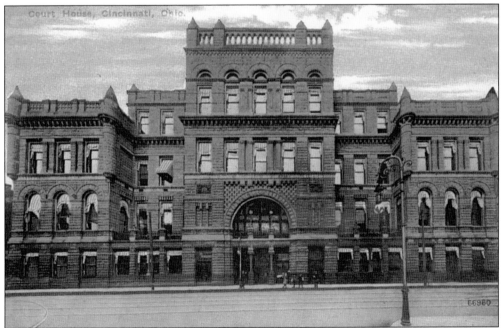

The first county courthouse erected at this site was a brick structure built in 1819. Thirty years later, it burned when flames jumped from a fire at an adjacent slaughterhouse. This view is of the third courthouse, constructed after the infamous 1884 riot that burned its predecessor. It served Hamilton County until 1914, when it became outmoded. William Howard Taft laid the cornerstone for the current courthouse in 1915.

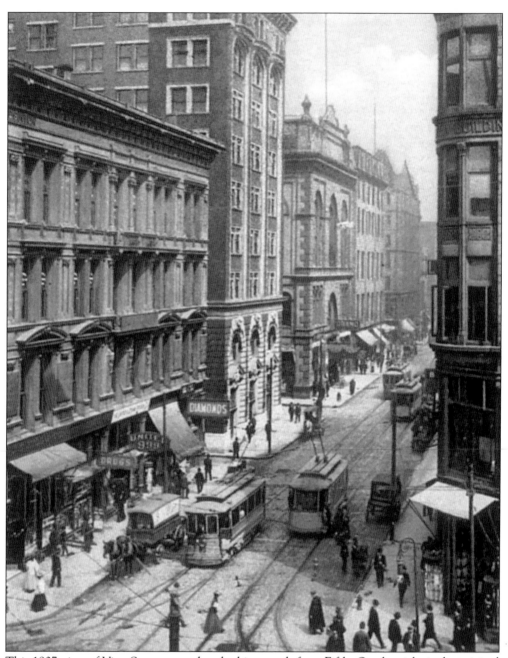

This 1907 view of Vine Street was taken looking north from Fifth. On the right is the original Mabley & Carew Department Store, which for years occupied the northeast corner of Fifth and Vine before finally moving to the northwest corner of this busy intersection. The four-story building across the street was later replaced by a twelve-story structure for the Rollman & Sons Department Store. After the Hotel Havlin closed, Rollman's purchased it, opened the adjoining walls, and expanded their retail space into the old hotel. Continuing north, the next facade is that of the Grand Opera House. This building replaced the original 1862 structure, destroyed by fire in 1901. At the southwest corner of Sixth and Vine is the Greenwood Building, home of the Ohio Mechanics Institute from 1848 to 1910.

The Young Men's Mercantile Library Association was founded in 1835, and has been in its 414 Walnut Street location since 1875. The library's first home on this site was in the "College Building," but the current structure was built in 1905. Located on the 11th floor, the library shares space with retail tenants. It is still a very active downtown reading club, attracting notable authors and speakers, as it has throughout its history.

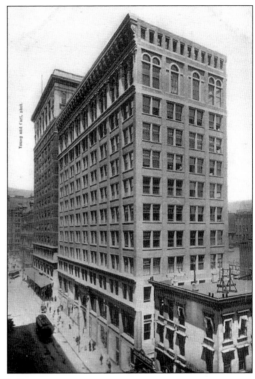

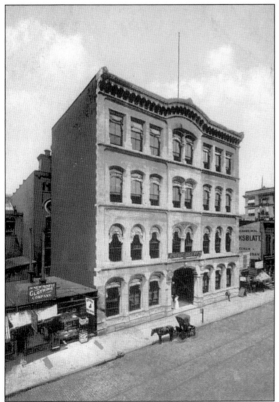

Located in this view on Vine Street between Sixth and Seventh, Cincinnati's first public library was originally formed in 1855, when small school libraries throughout the city were collected and placed in the rooms of the board of education. On February 26, 1874, the public library opened in a James McLaughlin-designed opera house that never was. The structure, a four-story auditorium with book stacks added around the perimeter, remained the library's home until 1955, when a new building was constructed at 800 Vine Street.

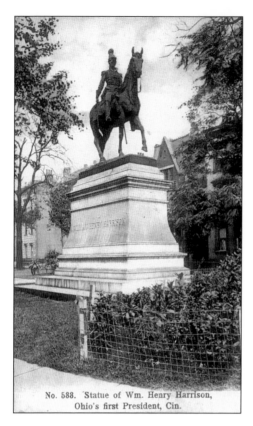

No. 588. Statue of Wm. Henry Harrison, Ohio's first President, Cin.

Dedicated in 1896, this equestrian statue of the ninth president of the United States, William Henry Harrison, was sculpted by Louis T. Rebisso, an instructor at the art academy. Harrison is featured in his military days, much younger and more vigorous than he was during his short presidency. It is the only equestrian statue in the city; yet Rebisso neglected to provide his subject with a saddle! Harrison's memorial was placed at the west end of Piatt Park in 1988.

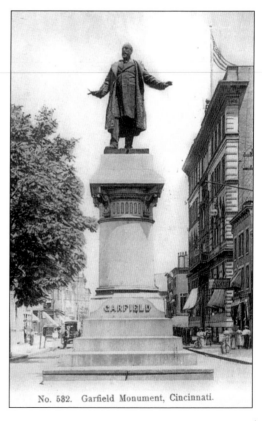

No. 582. Garfield Monument, Cincinnati.

The monument to Ohio-born James A. Garfield, our nation's 20th president, was cast in Rome, Italy, in 1885 by sculptor Charles Henry Niehaus. Two years later, it was installed in the middle of the intersection of Eighth and Race Streets, but was moved to the west end of Piatt Park in 1915, having become an obstruction to traffic. Following the 1988 renovation of the park, the statue was switched to the east end.

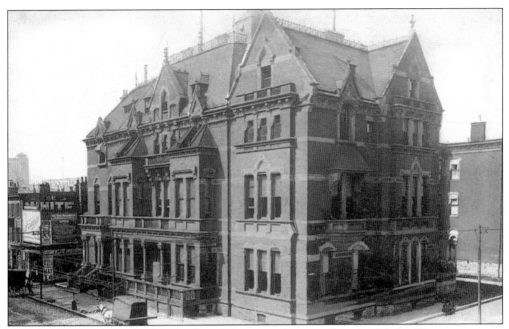

Founded in 1874 by philanthropist Joseph Longworth as an all-male club for "literary purposes and mutual improvement," the Queen City Club moved into this stately edifice in 1876. The location at the corner of Seventh and Elm was then a fashionable residential area, and Sinclair Lewis stayed here while researching his novel, *Babbitt*. In 1927, the Club moved to its present home at Fourth and Broadway.

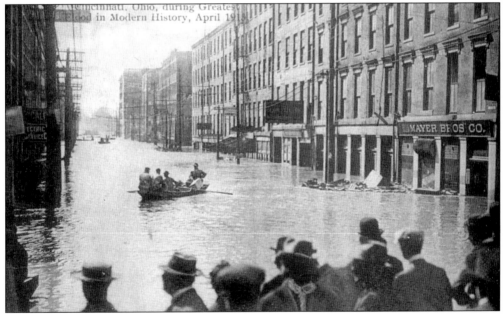

In this scene from April 1913, the curious gather to see rowboats replace streetcars on Walnut Street, below Third. At nearly 20-feet above flood stage, the 69.9-foot crest did qualify the 1913 flood as the "Greatest Flood in Modern History." Unfortunately, that honor was relatively short-lived: the 1937 flood surpassed it by 10 feet!

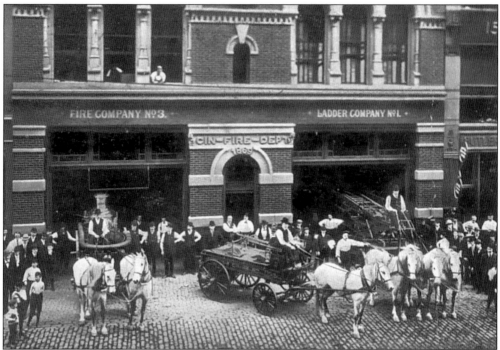

Under the leadership of industrialist Miles Greenwood, Cincinnati's first professional fire department was formed in 1853. It was the first company in the United States to combine paid employees, steam pumpers, and teams of horses to move men and equipment. This successful combination became the model for municipal fire departments for several decades. The department was headquartered at City Hall until the 1860s, when this firehouse was built near the corner of Sixth and Vine.

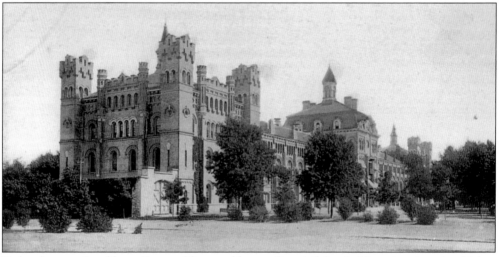

Today the term "workhouse" seems like an odd name for a jail, but in Victorian times hard labor served as both punishment and cure for criminal behavior. Designed by Samuel Hannaford and opened in 1869, this huge structure was located northwest of downtown, in the Camp Washington neighborhood. A cavernous, dank building, the workhouse was demolished in 1990, after being used in the filming of motion pictures.

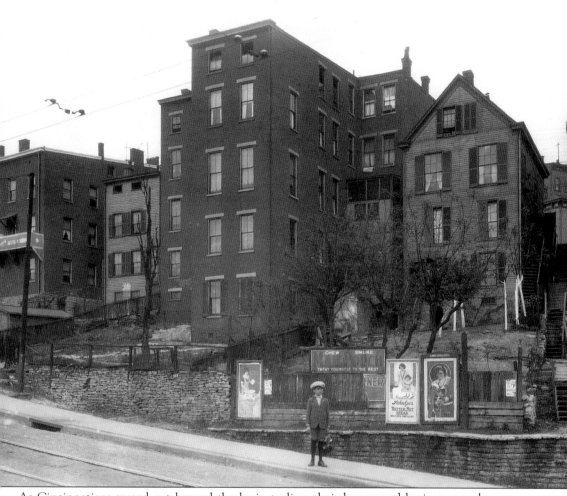

As Cincinnatians spread out beyond the basin to live, their homes and businesses took on a pattern that fit in with steep streets and narrow lots: steep houses on narrow lots. This photograph of the Brighton Bridge area just north of downtown, near the old Miami and Erie Canal, was taken in 1927. Besides the precipitous stairs and the fitted stone retaining walls, one can also see a few examples of neighborhood billboards for Butternut Bread and Mail Pouch Tobacco.

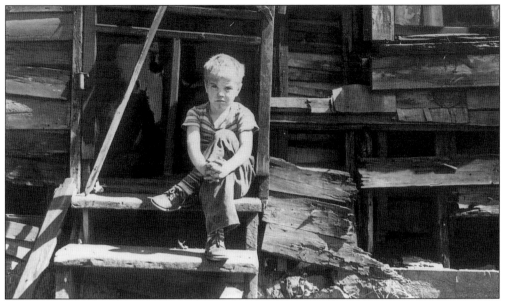

The Over-the-Rhine section of downtown deteriorated during much of the 20th century. Always a destination for 19th-century immigrant groups, and later, for Cincinnati's increasingly large Appalachian population, the area was often a marker for the city's poverty. In this 1940s image, documentary photographer Daniel Ransohoff provided a stark look at Over-the-Rhine's human context.

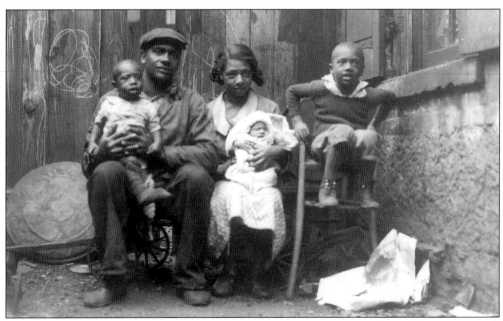

Over-the-Rhine became a target area for community improvement in the 20th century. Such organizations as the Public Health Federation, which took this photograph, and the Better Housing League worked to make correct sub-standard housing and provide health care for the poor. Clinics were established to teach hygiene and safety in an area where such things were at a premium. The Better Housing League, after nearly eighty years, is still one of the city's strongest advocates for social care and housing assistance for Cincinnati.

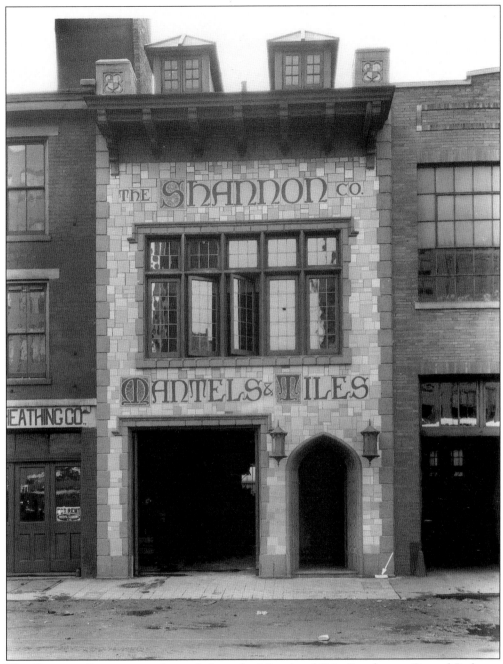

The Shannon Company was located along the Miami and Erie Canal, now Central Parkway. When the ill-fated Cincinnati subway was being constructed along this route in the 1920s, a project photographer for the city engineer's office and the rapid transit commission followed every step of the way. His duties were to make a visual record of all the work, and also to document any damage that may have occurred as the canal bed was widened and deepened. His little white arrow near the bottom right was imposed on the image to show a possible crack, and thus a possible damage claim from the building's owners. The facade of the building was advertising of the first sort, as if to say: "This is what we are about."

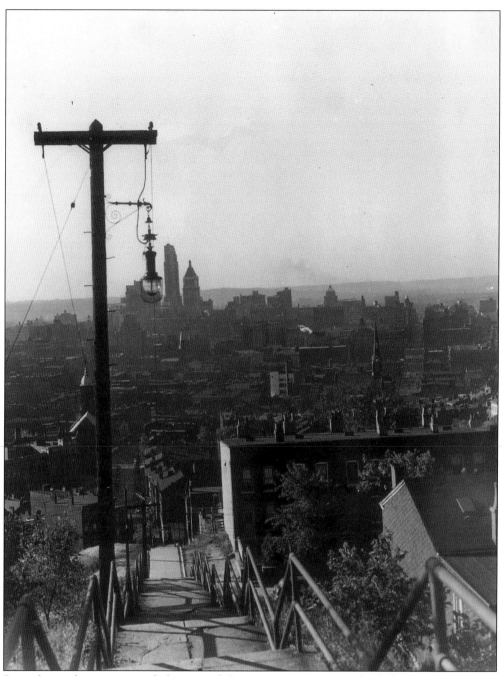

Several set of steps surround the city of Cincinnati, connecting the hillsides to the basin. Narrow and steep, they provide a path between streets, and at their summit, offer a spectacular view of the downtown landscape. This particular view was taken by Daniel Ransohoff in 1941 as part of his documentary work for the Better Housing League.

Two

TAKING CARE OF BUSINESS

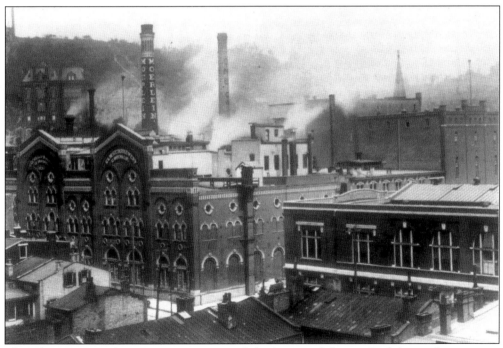

The Christian Moerlein Brewery was one of the largest of the pre-Prohibition breweries in Cincinnati, and one of the largest in the country, with sales extending south and west far beyond the city's boundaries. The brewery building itself was also an example of the large place that beer held in Cincinnati culture. The huge, modern edifice was a testament to an architectural style that proclaimed the modern factory as every bit as important in local life as city halls, churches, stores, train stations, and ballparks.

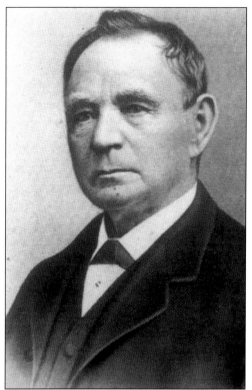

Christian Moerlein himself was a Cincinnati success story. Born in Bavaria in 1818, Moerlein grew up working on his father's farm, but when he reached his teens, he left home to become an itinerant worker throughout Europe. In 1842, Moerlein arrived in Cincinnati where he worked first digging cellars and then, blacksmithing. By 1853, he had started a small brewery. Forty years later, it would be the largest in Ohio.

Most of the brewers were German-born or second-generation Germans; most of the workers were the same, as were the customers. Beer was more than a drink in Cincinnati; it was part of the social fabric. This early photo shows a Hudepohl Brewery company picnic. Prominently featured, of course, is the company's product. And it wouldn't have been any sort of picnic for Ludwig Hudepohl if there weren't music and a show of patriotism.

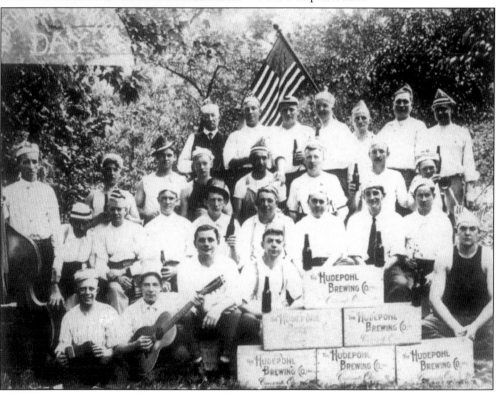

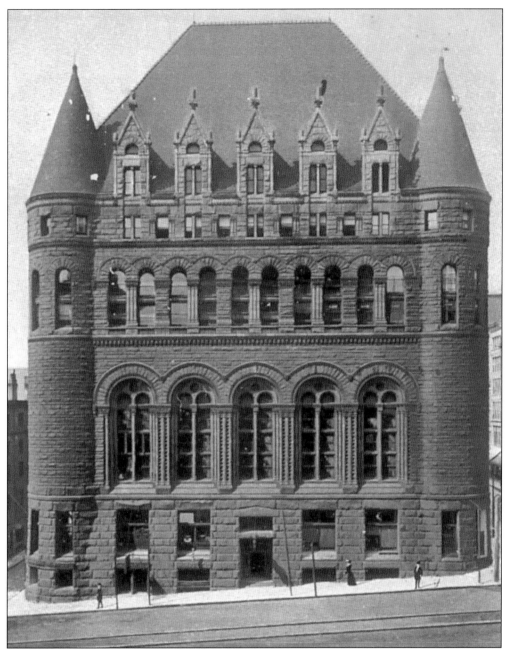

The Chamber of Commerce Building was designed by noted architect H.H. Richardson and constructed after his death in 1886 at the southwest corner of Fourth and Vine Streets. On the night of January 10, 1911, a fire in its upper stories got out of control and this allegedly fireproof building burned. Though its walls remained standing, it was determined irreparable. The stone eagles that once perched on the dormer windows now flank Eden Park Drive, on either side of the arch bridge. Sections of the building long-sat in Miami Heights for eventual use in an astronomy observatory, but it never came about. In the mid 1980s, architecture students at the University of Cincinnati recovered some of the fragments and composed them in a Burnet Woods sculpture dubbed "Stonehenge."

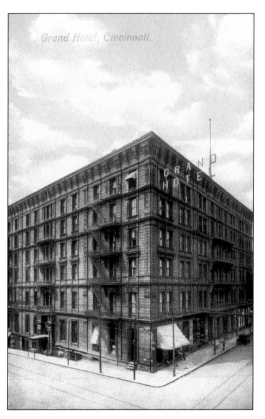

These two views show the Grand Hotel, noted for its "direct-acting hydraulic passenger elevator" with a 90-foot shaft. Designed by Peck, Hannaford and Peck, and built in 1874, the Grand covered almost an acre of land at the corner of West Fourth Street and Central Avenue. Construction cost $800,000, with another $250,000 spent on furnishings for the 285 rooms and the opulent lobby. The Republican National Convention was held here in 1876, accommodating the delegates from eight states. Rutherford B. Hayes captured the nomination and addressed the convention from the lobby stairway. With the Great Depression and the eastward movement of the city, the great hotel became unprofitable and closed on June 30, 1933.

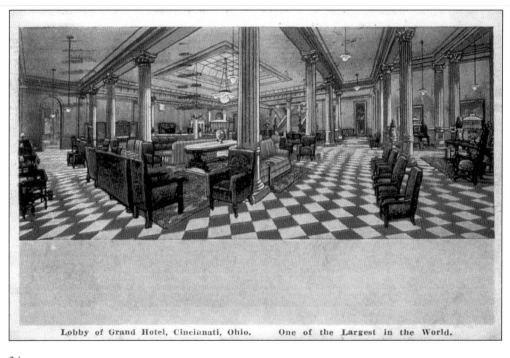

Lobby of Grand Hotel, Cincinnati, Ohio. One of the Largest in the World.

The magnificence of the Hotel Sinton and its lobby can be seen in these images, but a previous building on the site—Pike's Opera House—was just as fabulous. The opera house opened on the southeast corner of Fourth and Vine Streets in 1859, holding more than three thousand people, who could step through 13 entrances onto a spectacular black and white marble floor. Before it first burned in 1866, the building featured singer Adelina Patti in 1860, and the abolitionist Wendell Phillips in 1862, who delivered a fiery lecture on "Slavery and the War." Rebuilt in 1866, the opera house burned for its second, and last time, in 1903. The Sinton was then built on the site. Called the city's most stylish hotel, the Sinton was an imposing French Second-Empire-style building of reinforced concrete and a distinctive mansard roof.

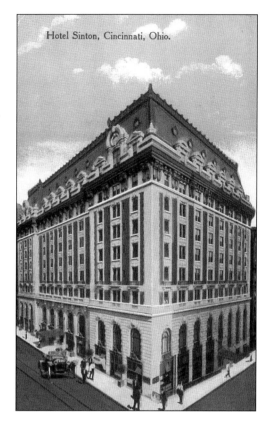

Hotel Sinton, Cincinnati, Ohio.

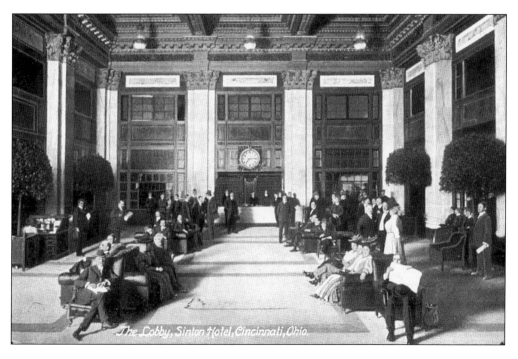

The Lobby, Sinton Hotel, Cincinnati, Ohio.

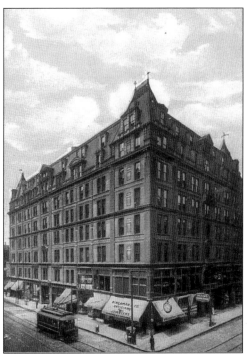

The Palace Hotel, now the Cincinnatian, has occupied the northwest corner of Sixth and Vine since 1882. Designed by Samuel Hannaford and Sons, it is downtown's finest remaining French Second-Empire-style building. A dramatic 1987 renovation left the exterior largely unchanged, but gave the old hotel a stylish, contemporary interior, complete with a skylighted, eight-story atrium.

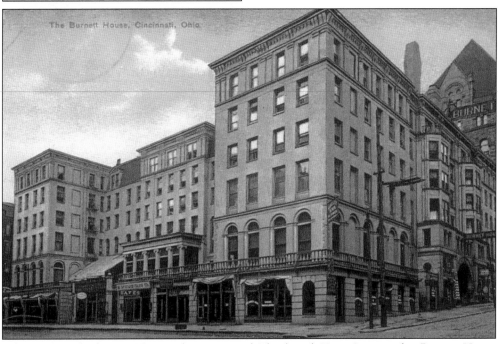

When it was built in 1850, at the corner of Third and Vine Streets, the Burnet House was considered to be the grandest hotel in the country. Its architect, Isaiah Rogers, was often referred to as the father of the modern hotel. Such luminaries as Sarah Bernhardt, Horace Greeley, Henry Clay, Abraham Lincoln, and Daniel Webster slept here. It was in the Burnett that Generals U.S. Grant and William T. Sherman planned the latter's Civil War march through Georgia.

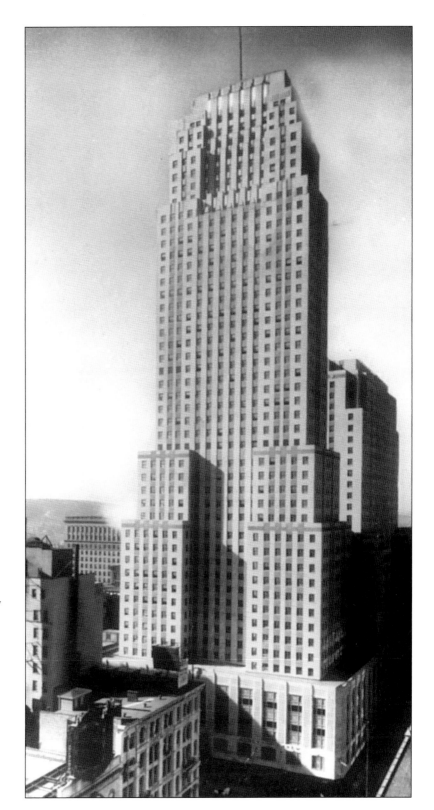

At 574 feet, Carew Tower is Cincinnati's tallest building. Part of a large complex along Fifth Street, between Race and Vine, the structure was built in 1930 by the same firm that built the Empire State Building the following year. The Carew Tower was one of the early "mixed-use" buildings, and has dominated the skyline for over 70 years.

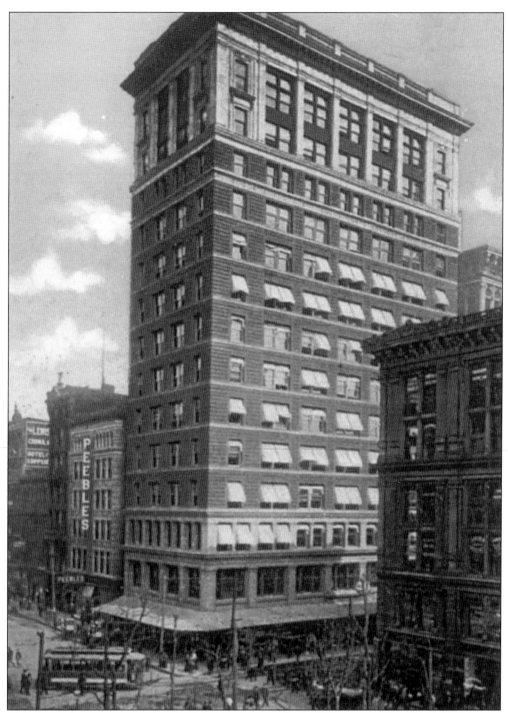

Designed by architect Daniel H. Burnham, the Traction Building (now Tri-State Building) was erected in 1902 at the southeast corner of Fifth and Walnut. It was built for the Cincinnati Street Railway Company and is a colorful example of the three-part high-rise design typical of the era. The pink granite base supports nine stories of multi-shaded, red brick masonry, capped by a limestone top.

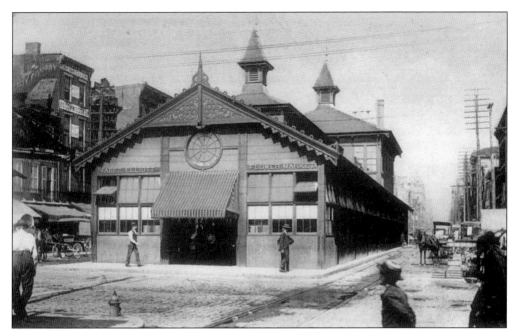

When Mary E. Holroyd died in 1890, she left the city $15,000 to build a flower market in memory of her first husband, Jabez Elliot. City Council accepted the offer and provided a suitable site in the middle of Sixth Street, between Elm and Plum. The 200-foot structure formally opened on March 15, 1894.

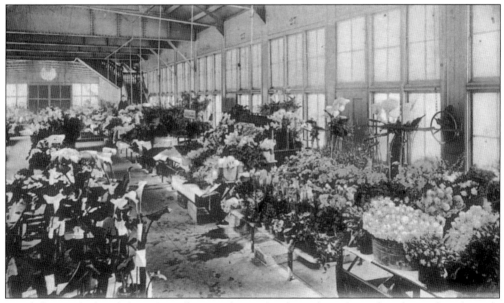

Local florists declared the Jabez Elliot Market to be the only such market devoted exclusively to flowers in the United States. For years it was the scene of magnificent weekly floral displays created by members of the Cincinnati Florists Society, whose meeting hall was on the second floor. As demand for flowers downtown died when suburban shops opened, the market fell into decline and was demolished in 1950.

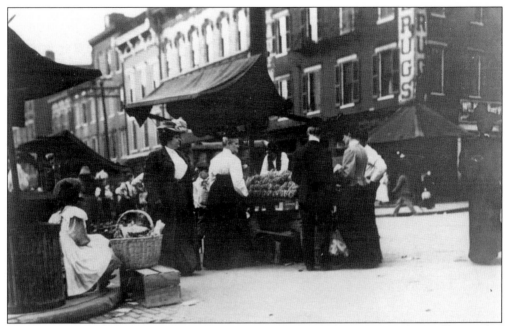

Named for General James Findlay, a Cincinnati veteran of the War of 1812, the Findlay Market has been in business since 1852. It was the seventh of the city's public markets, a landmark place for public meetings and shopping. A focal point of the Over-the-Rhine neighborhood, this 1900 view shows some of the produce sellers.

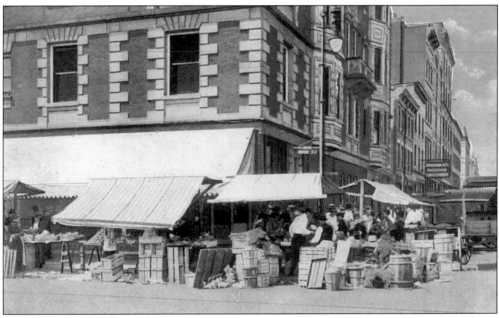

In the last decades of the 1800s, Court Street's proximity to the Miami and Erie Canal (now Central Parkway) made it an important commercial area. The first market was built in 1829, and then replaced in the mid 1860s by a similar open-air structure. Since 1915, a curbside market has endured with merchants using stands, stalls, and carts to display their produce on Tuesdays and Thursdays.

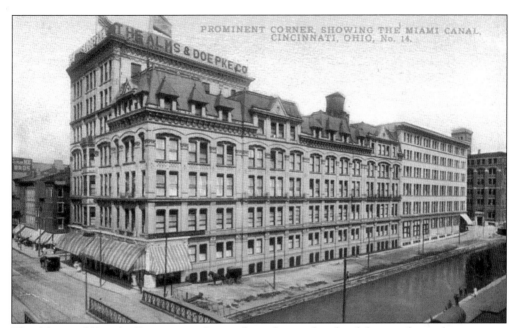

The Alms and Doepke Department Store, along the north side of the canal, was for years one of Cincinnati's largest retailers. Founded in 1865 by brothers Frederick and William Alms and their cousin William Doepke, the store moved to this site in 1878. Over the next several decades, the company's fortunes increased, and its impressive physical presence followed suit. Hamilton County government offices now occupy much of the building.

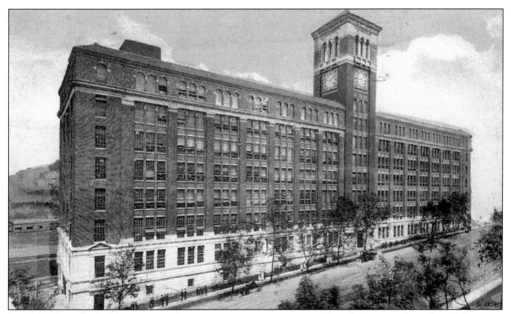

In 1862, Dwight Baldwin opened a one-room music store on Fourth Street where he sold pianos and organs. Baldwin began making his own instruments in 1890, and this building, completed in 1920, and located on Gilbert Avenue opposite Eden Park, served as the assembly department and housed company offices. In 1986, Corporex, a real estate development firm, renovated this structure into an office building.

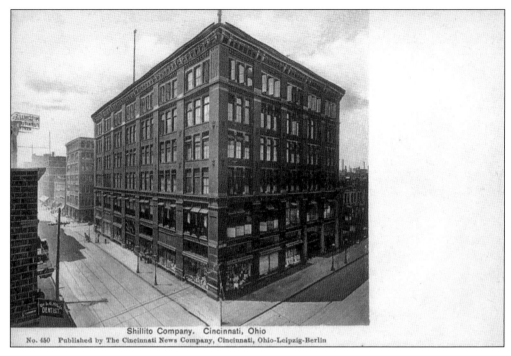

Shillito Company. Cincinnati, Ohio
No. 450 Published by The Cincinnati News Company, Cincinnati, Ohio-Leipzig-Berlin

A landmark for generations, Shillito's had its beginnings in 1830, when John Shillito opened a dry goods store. When this building opened on Seventh Street in 1878, it housed the largest department store in the country under one roof. It boasted a multi-storied atrium 120 feet high with a glass dome 60 feet across. In 1938, the store was modernized with an Art Deco facade. A Cincinnati institution, Shillito's Department Store is now known as Lazarus. One of its downtown counterparts was Pogue's, another fine store. In this view from 1902, customers are awaited by the clerks in the men's furnishings department.

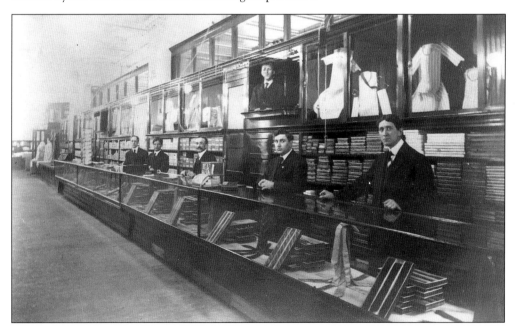

Three

GETTING FROM HERE TO THERE

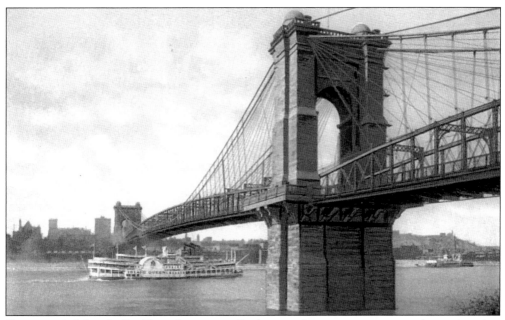

Cincinnati's John A. Roebling Suspension Bridge stands as a monument to the engineering genius of its creator. In 1846, Roebling submitted plans to the Covington and Cincinnati Bridge Company for a suspension bridge across the Ohio River. After 20 years of political wrangling and Civil War delays, the bridge officially opened on January 1, 1867. With a central span of 1,057 feet, it was the longest suspension bridge in the world, and remained so until Roebling's Brooklyn Bridge opened in 1883.

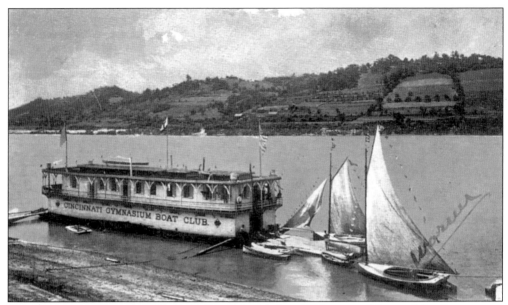

The Cincinnati Gymnasium Boat Club was founded in 1890 as an offshoot of the Gymnasium and Athletic Club for the members who were boating enthusiasts. In 1892, funds were raised for the boathouse seen here, and it served the club for over 35 years. In 1928, it was moved upstream near Coney Island, where it sank a year later.

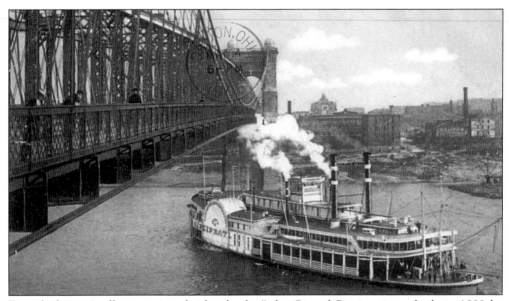

Described as a "well proportioned side-wheeler," the *City of Cincinnati* was built in 1899 by the famous Howard Shipyards of Jeffersonville, Indiana. Teamed with the nearly identical *City of Louisville*, both boats were destroyed in 1918, when the frozen Ohio River broke up. The powerful crushing force of the ice splintered the boats' wooden hulls.

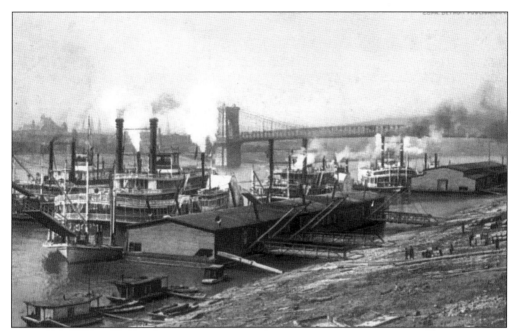

This Ohio River view shows Cincinnati's Public Landing in 1907. The boat in the left foreground is the Coney Island Company's first *Island Queen*. At the far right is the Louisville and Cincinnati Packet Company's wharfboat. In the hazy distance is the Suspension Bridge, which prior to its completion 40 years earlier was vehemently opposed by steamboaters convinced that it would obstruct navigation and their livelihood.

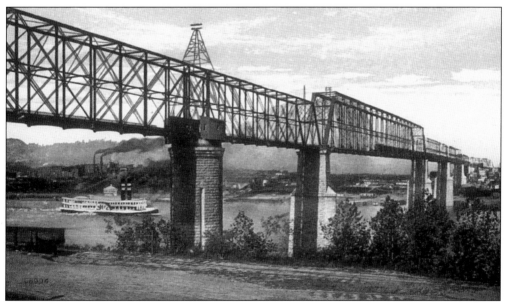

At the end of the Civil War, Cincinnati was eager to re-establish trade with its southern markets. Rail transportation was the way of the future, so with a grand banquet at Music Hall in 1880, the Cincinnati Southern Railway was opened. The line ran south to Chattanooga—a hub to other southern cities. This railway bridge, downstream from the Suspension Bridge, is still in use.

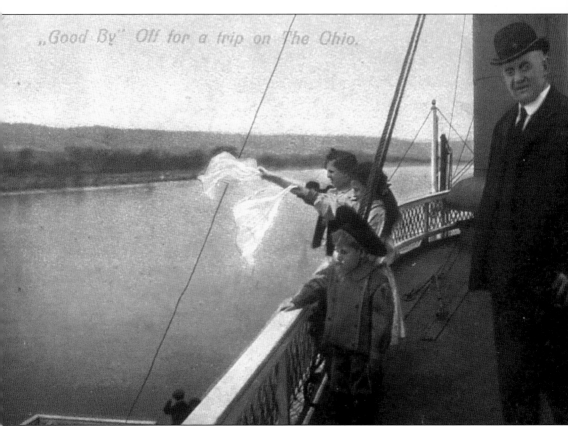

„Good By" Off for a trip on The Ohio.

In 1884, Albert Otto Kraemer began assembling photographic views of the Cincinnati area, most of which he commissioned from professional photographers. In 1898, he published the first edition of a very popular book, *Picturesque Cincinnati*. In 1902, Kraemer entered the postcard business. He is shown in this card posing aboard a Cincinnati riverboat for one of his photographers.

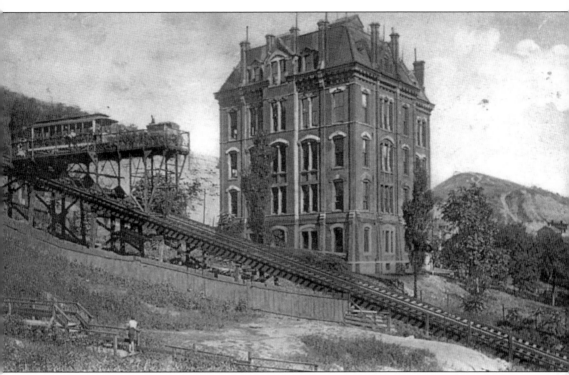

The city's tremendous growth during the first half of the 1800s quickly claimed the easily-traveled flat land known as the "basin." The wealthy had already moved to the hilltops, but those of lesser means needed a dependable and affordable conveyance: thus, the development of the inclined-plane railway. This view is of the Elm Street Incline running next to the original building of the University of Cincinnati. After UC moved to Burnet Woods in 1895, the building served a number of purposes, including the university's College of Medicine. Commuters often complained about the medical students' jolly habit of waving dismembered arms and legs out the windows as the trolleys passed.

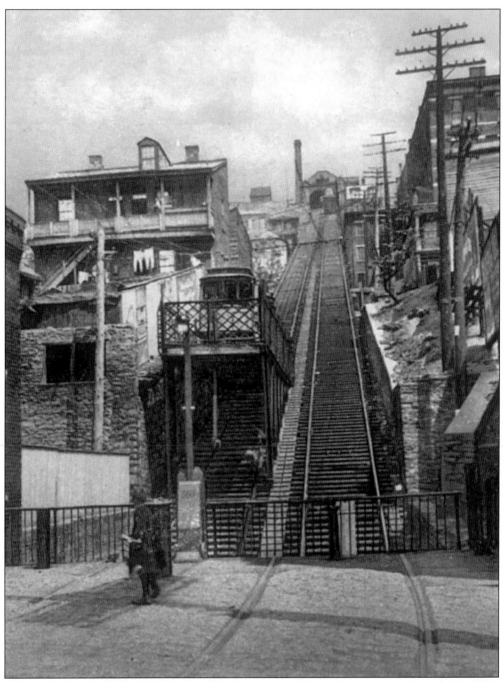

The Mt. Adams and Eden Park Inclined Railway opened for regular service on March 12, 1876. It was 945 feet long and rose 270 feet above the lower station. Originally, it had fixed cars that carried only passengers. These were removed in November 1879, to accommodate streetcars. The Mt. Adams Incline was in service longer than any other, finally ceasing operation in 1948. While the views from the incline's heights may have been celestial, the view here proves that those from the bottom of the hill were much more earthy—long underwear hangs out to dry on the porch just to the left of the track!

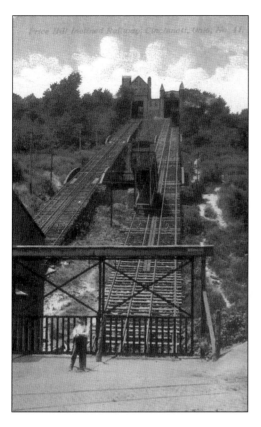

The Price Hill Incline on West Eighth Street was actually two inclines with four parallel tracks. The left side opened in 1874 and had two fixed cars for passengers. In 1876, the right side began operating with two platforms that could carry several heavily loaded wagons with teams. In 1906, the cable snapped, sending horses and wagons to the bottom. Both drivers survived, one by throwing himself into his wagon loaded with manure.

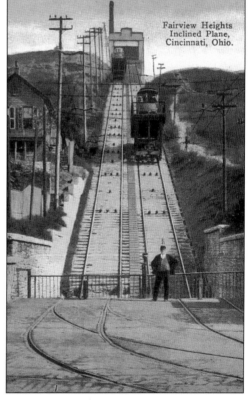

The last of the inclines to be built, the Fairview Heights Inclined Plane was constructed in 1892, and was designed to carry electric streetcars to Clifton Heights and back. The incline closed to streetcars in 1921, and stationary car bodies for passengers were mounted. The incline closed on Christmas Eve, 1923.

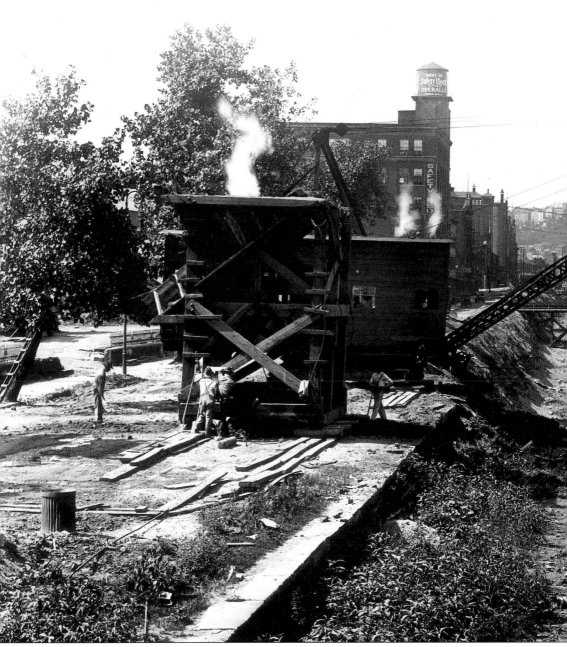

Seeking a way to move its citizens quickly from the outer suburbs to jobs and shopping downtown in the years before World War I, Cincinnati decided to construct a subway system in the abandoned Miami and Erie Canal bed. The way of the canal boats had long since passed, and the ditch—for that is the only way you could term it—was occasionally filled in lower spots with brackish, stagnant water, a natural breeding ground for mosquitoes. Other stretches

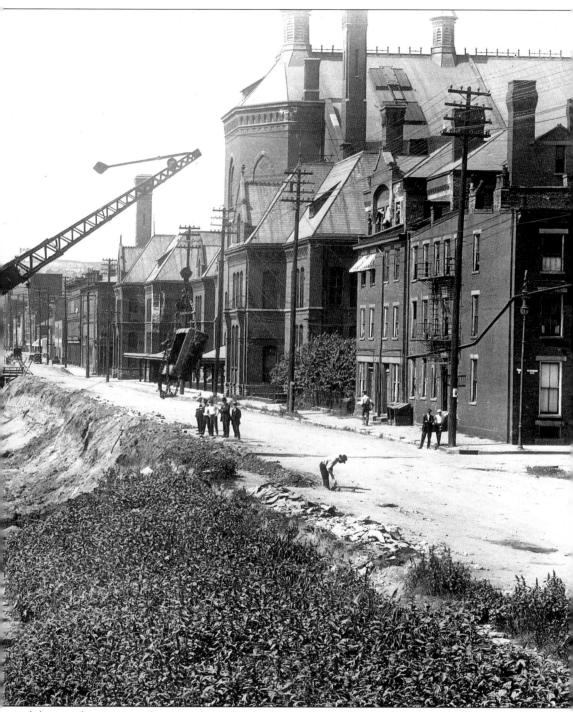

of the canal, as it wound its way from the northern suburbs through downtown, was nothing more than a convenient dumping ground for trash and debris. Narrow footbridges and the wider vehicle bridges that connected one side of the city's streets to the other side looked over nothing but a weed-choked eyesore.

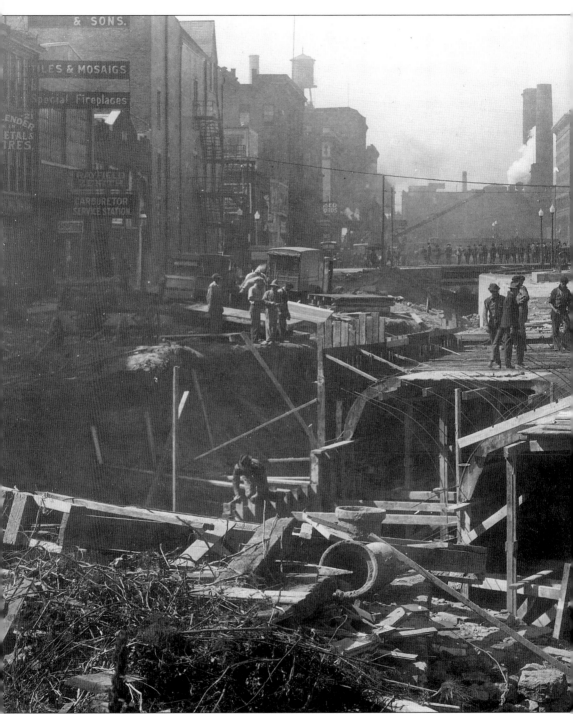

Planning for the subway system actually began in 1915, when the state legislature created the Board of Rapid Transit Commissioners. The next year, the commission issued $6 million in bonds to fund the construction. The plan was to encircle the residential areas and bisect the downtown district with 2.45 miles of subway, 9 miles of open track, 20 miles of tunnel, 3.4 miles of trestles, and 1.4 miles of other elevated structures. The subway cars, traveling at

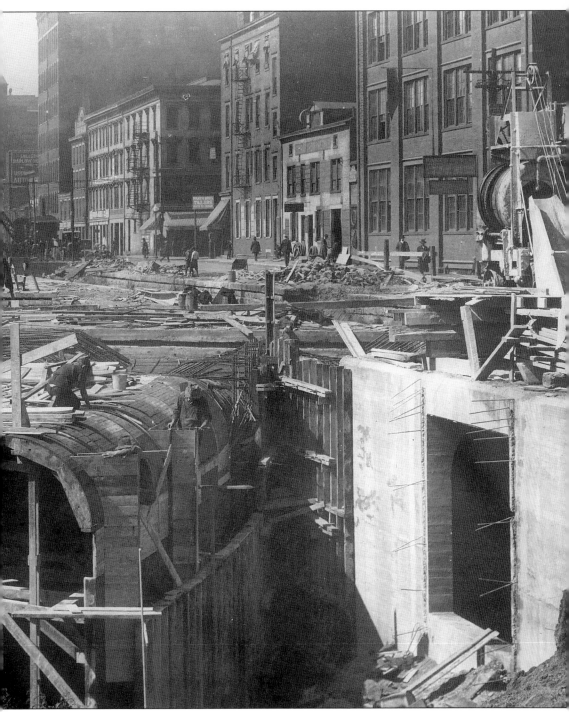

45 miles per hour, were to be spaced at 69-second intervals and were to be grouped in four-car trains. Estimates were that 110,000 passengers could be moved each hour. The old canal bed would have to be widened and deepened. World War I intervened, but on January 28, 1920, construction began with the excavation of the section of bed at Walnut Street.

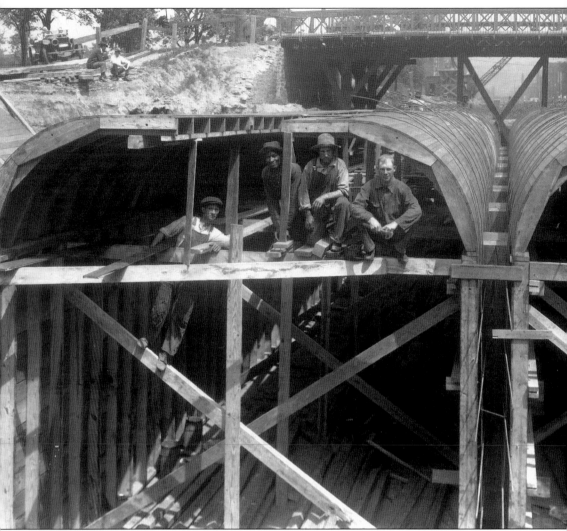

But there is a reason the subway project is now referred to as Cincinnati's "white elephant." From the beginning, the project was plagued with engineers' miscalculations, cost overruns, political graft, and dissension—and a very basic change in transportation patterns: America was more and more becoming the land of the automobile. Property owners along the route filed damage claims when their building foundations and walls were cracked by the excavation and construction. By 1928, it was estimated that another $13 million would be required for the subway. The project was then shut down. Today, the subway's route is instead Central Parkway. Scattered sections of tunnels still remain, and over the years it has been proposed to use them for such various projects as Civil Defense supply storage, mushroom farming, wind tunnel experiments, and movie sets.

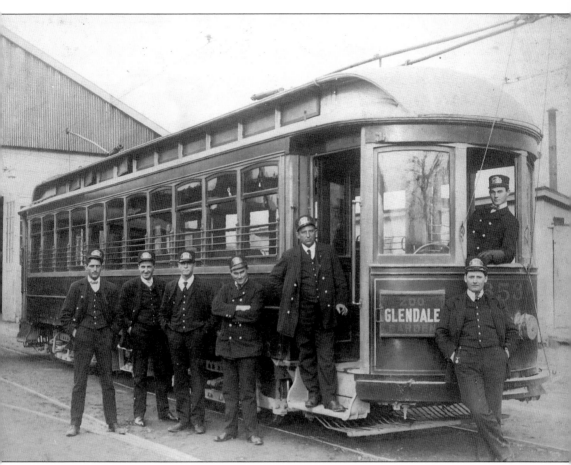

The lack of a subway did not mean there was no public transportation, however. From the inclines, to the streetcars, to the modern mass transit system, Cincinnati has always accommodated the public traveler. This view of one of the city's electric trolleys shows a group of conductors posed with the Zoo-Glendale streetcar.

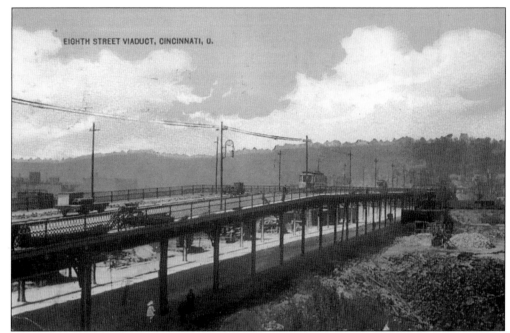

EIGHTH STREET VIADUCT, CINCINNATI, O.

Record flooding of the river in 1883 and 1884 caused the Mill Creek to overflow its banks into the entire West End bottomland. West Eighth Street, the primary connector between downtown and Price Hill, was completely blocked by high water. In 1893, the viaduct opened after years of planning and delays. The structure seen here was replaced by the current one, which was built from 1926 to 1928.

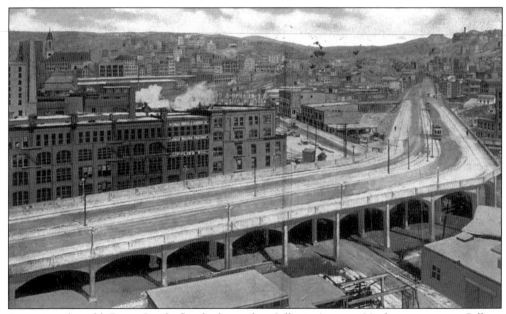

Spanning the old Deer Creek flood plain, the Gilbert Avenue Viaduct connects Gilbert Avenue with the eastern edge of downtown. The structure shown here was built in 1912, and was 1,216 feet long. It reached an advanced state of deterioration before being demolished and replaced in 1985.

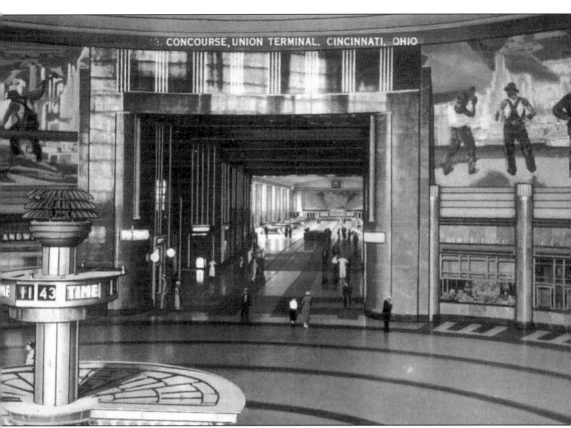

The Union Terminal concourse extended from the rear of the rotunda and was built above 16 tracks and 8 platforms where passengers would board. The concourse was 450 feet long and contained 14 mosaic murals depicting scenes of Cincinnati's leading industries. Designed by Winold Reiss, the murals were executed in small colored-glass pieces called "terasse." In 1972, just before the concourse was demolished, the murals were removed to their current home in the Greater Cincinnati Airport.

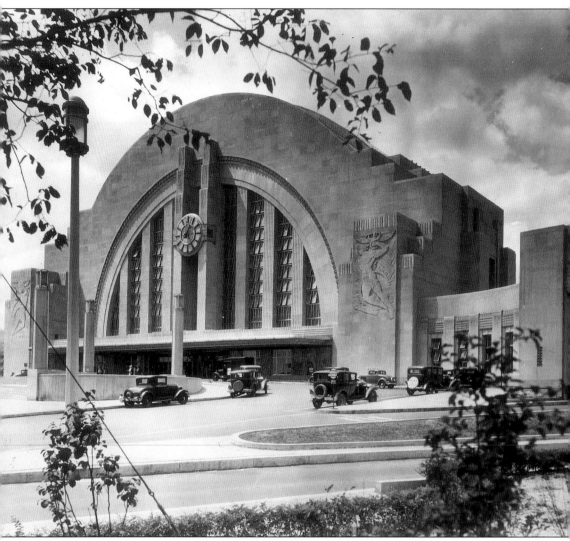

Designed by the New York firm of Fellheimer and Wagner, the city's Union Terminal was originally a self-sustaining complex of 22 distinct buildings. Work began in August 1929, and was completed in March 1933. Behind its magnificent art deco facade is the largest free standing half-dome in the western hemisphere, with a span of 180 feet and a height of 106 feet. The train station operated at its full capacity of 216 daily trains only during World War II, and as rail travel diminished, so did Union Terminal. In 1986, after a failed life as a shopping mall, local voters passed a tax levy to convert it to its present incarnation as the Cincinnati Museum Center.

Four

A CITY OF NEIGHBORHOODS

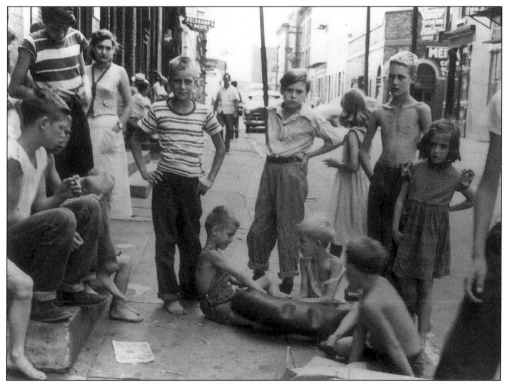

More than anything, Cincinnati is a city of neighborhoods. People identify themselves by saying which area of the city they live in, and part of the vibrancy of the city lies in these residential compositions. This view of the Over-the-Rhine neighborhood in the 1950s, by Daniel Ransohoff, shows part of Cincinnati's Appalachian community.

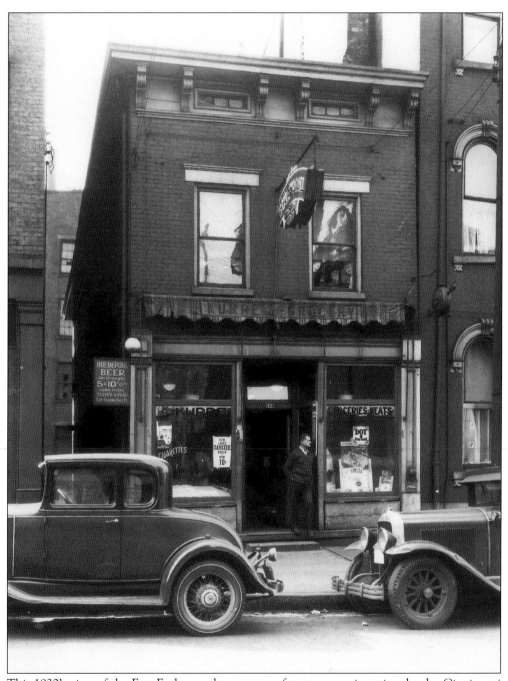

This 1920's view of the East End was taken as part of a street repair project by the Cincinnati Planning Commission. As a community document, the photograph is more valuable than its original intent, as it illustrates and preserves a slice of everyday urban life.

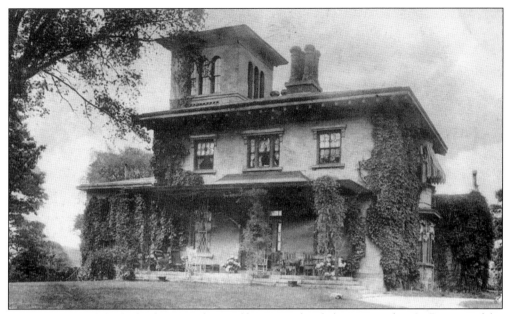

Joseph Longworth built this house and moved his young family here around 1850. Because of the many crows that roosted in the trees on the property, he named the estate "Rookwood." When Joseph's daughter Maria established an art pottery in 1880, she chose the name Rookwood, after her childhood home and because of the similarity of its name to "Wedgwood."

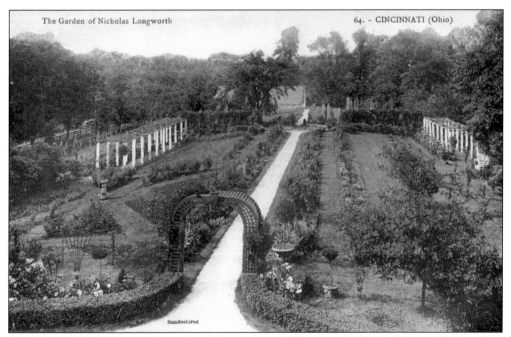

Joseph's son Nicholas was elected to Congress in 1899, married Teddy Roosevelt's daughter Alice in 1906, and became Speaker of the House of Representatives in the 1920s. Whenever the Longworths visited Cincinnati, Rookwood hosted the social elite. The gardens provided an array of seasonal flowers and fruit used while entertaining.

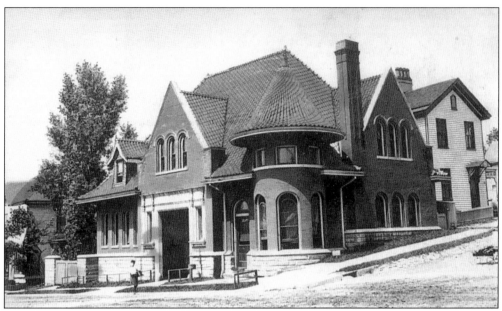

Built at the corner of Columbia Parkway and Delta Avenue in 1901, this structure served as the East End's Police Station for many years. A very successful example of adaptive re-use, the building was remodeled in 1981 and opened as a restaurant and popular night spot appropriately named "The Precinct."

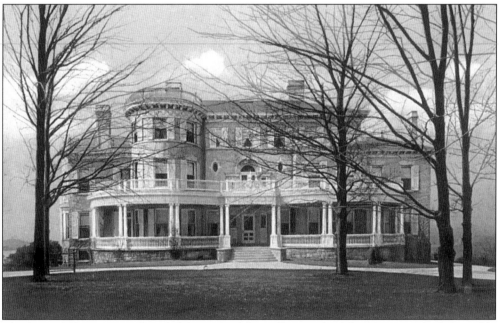

This beautiful house, named "Wiladel," was built by William and Adele Oskamp in the fashionable suburb of Westwood. It was completed in 1896 for the then-substantial sum of $40,000. Oskamp was a successful jeweler and silver manufacturer. His wife was the daughter of soap company founder, Michael Werk. The home is now part of the Judson Village Retirement Community.

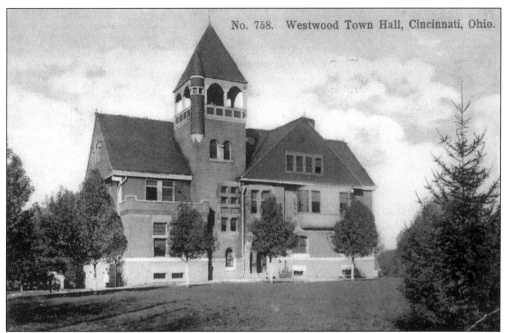

Located at the northwest corner of Harrison and Montana Avenues, the Westwood Town Hall has been serving Westwood residents since 1889. This predominantly brick structure initially housed public meeting rooms, village offices, and the volunteer fire department. From 1929 to 1966, it was leased by the Gamble-Nippert YMCA. Now renovated, it continues to be used for various community activities.

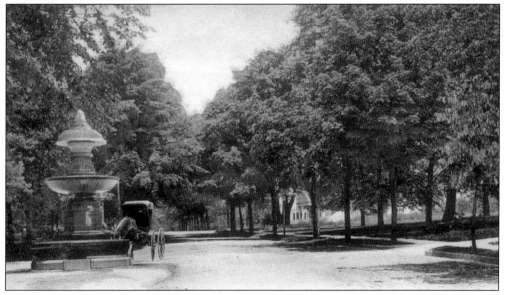

Situated on the west side of Clifton Avenue, this fountain was presented by Henry Probasco to the village of Clifton in 1887. Designed by Samuel Hannaford, it is made of granite and bronze, and stands 10 feet tall. The top basin was designed for use, with an attached dipper, as a drinking fountain. The lower basin was for watering horses, and at ground level there are even side bowls that provide water for thirsty dogs.

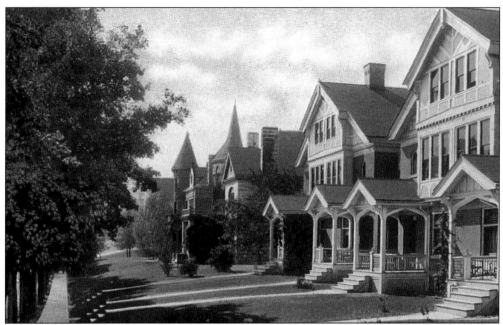

Clifton's first residents were gentlemen farmers and wealthy businessmen who purchased the hilltop property to build lavish homes, away from the overcrowding and pollution of the urban center. Even as the population grew, and the older estates were subdivided, Clifton continued to be known for its well-appointed homes.

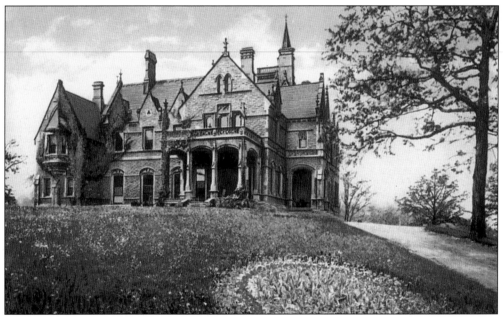

A Clifton landmark since 1867, "Scarlet Oaks" was built by iron magnate George K. Schoenberger. E.H. Huenefeld purchased the estate and presented it to the Methodist Church for use as a sanitarium in 1908. Now occupied by the Bethesda Home for the Aged, residents live in several adjoining buildings. The restored mansion houses a chapel, library, beauty shop, and craft and recreational facilities.

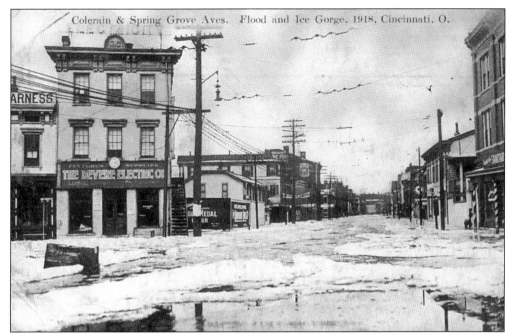

This postcard view of Knowlton's Corner shows the busy north side neighborhood intersection covered by floodwater from the nearby Mill Creek.

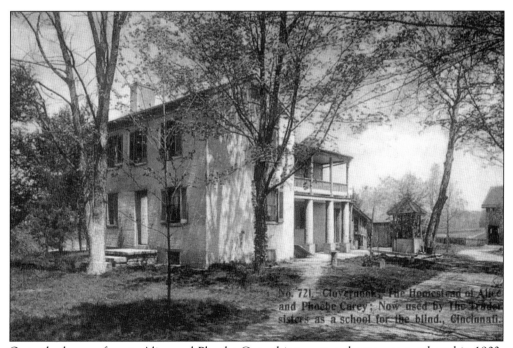

Once the home of poets Alice and Phoebe Cary, this two-story home was purchased in 1903, by William Cooper Procter. Here Procter started the Clovernook Home for the Blind. In this North College Hill facility embossed books were published as well as a Braille periodical entitled "Radio News."

College Hill, north and west of downtown along Hamilton Avenue, was so-named because of the educational institutions created there. Originally called Pleasant Hill because of the attractiveness of its setting—and because it was a relatively healthy area to live, outside of the outbreaks of disease in the crowded urban neighborhoods—the village was the site of Freeman Cary's school for young men, the Pleasant Hill Academy, in 1832. Reorganized as the Farmer's College in 1846, the school soon had as a neighbor the Ohio Female College. Residents appropriately renamed the village College Hill in 1866. This view is of the College Hill Hotel in 1911, showing the area then as a relatively bucolic spot.

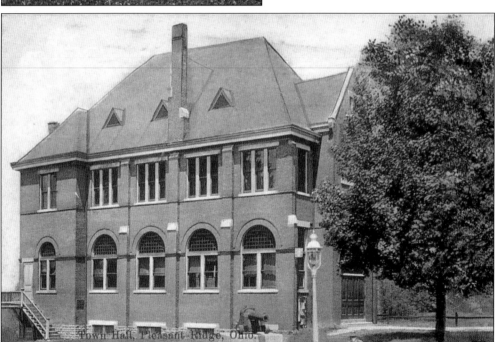

This impressive structure was built in 1884, as a town hall for Columbia Township, of which Pleasant Ridge was the seat. After Pleasant Ridge was incorporated as a village in 1891, this building housed all the municipal offices. The Pleasant Ridge Masonic Lodge No. 282 bought the building in 1912, when the village was annexed by Cincinnati.

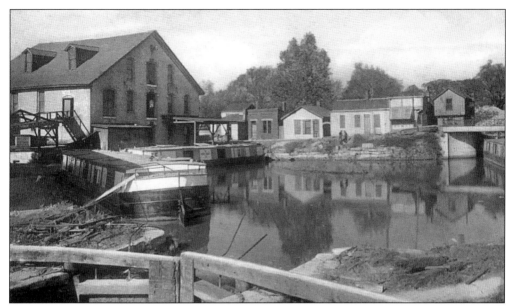

With the completion of the Miami and Erie Canal in 1829, speculators Nicholas Longworth and Lewis Howell laid out a village at the northern end of the Mill Creek Valley. Situated around the canal's locks, the village of "Lockland" was incorporated in 1849, and over the next century became a major center for mills and factories.

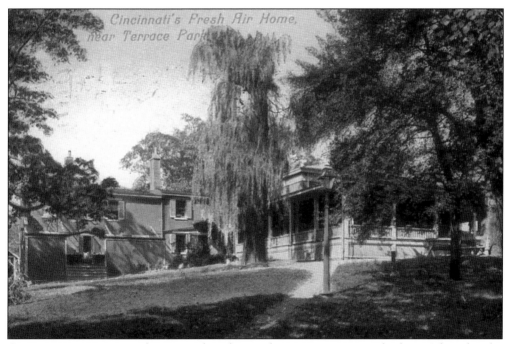

Cincinnati was active in the national settlement house movement in the late-19th and early-20th centuries, providing citizenship, job training, and sports programs for immigrants and poor urban families. A "fresh air" home was established in the eastern suburb of Terrace Park so that inner-city children could escape the smog and dangers of their neighborhoods. Today it is the site of the Stepping Stones Center for the handicapped.

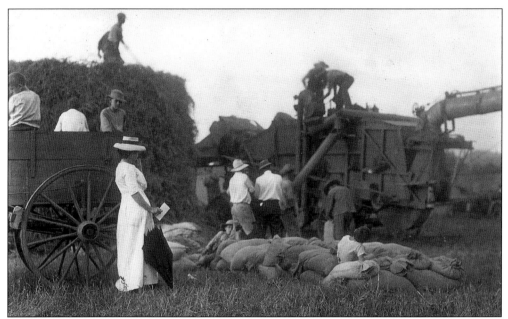

Beyond the corporate limits of Cincinnati were neighborhoods that eventually would be annexed by the city. This photo is of the Pfau family farm in Hartwell shortly after the turn of the 20th century. Where this farm stood is now a sprawling retirement community, and across Galbraith Road from it is Hamilton County's Drake Hospital.

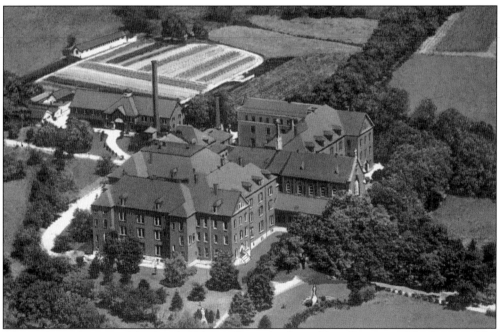

Also in the outlying neighborhood of Hartwell was the Saint Clare Convent of the Sisters of the Poor of Saint Francis. The convent grounds had its own working farm as well, along with a lovely church. The convent's buildings still remain as part of a retirement complex for the religious.

Five

BENEFACTORS AND SCALAWAGS

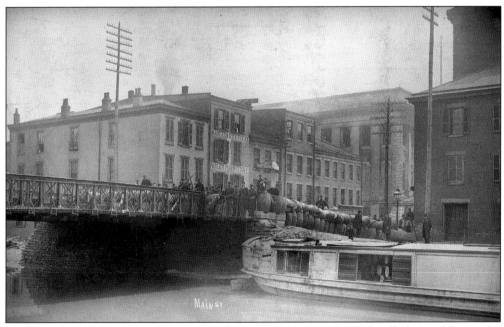

In the 1880s, Cincinnati was teeming, boisterous, and smoky with all the problems of a large 19th-century city. Political corruption was rampant and there were frequent tensions between ethnic immigrants and native-born citizens, between management and unions, and between races—often resulting in violent confrontation. In 1884, Cincinnati experienced one of its lowest moments when a citizens' meeting turned into a riot that destroyed the Hamilton County courthouse.

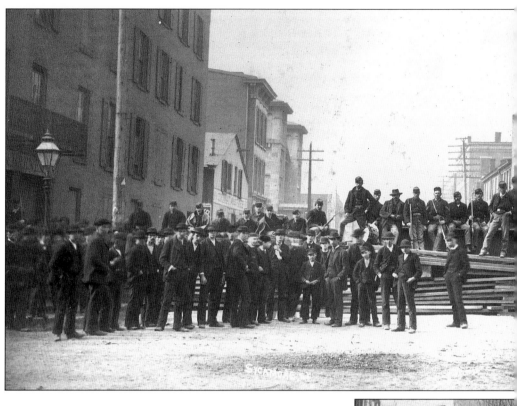

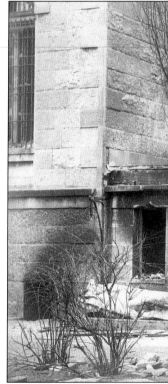

In protest over the growing corruption in the judicial system, a group of citizens gathered at Music Hall on the night of March 28, 1884. The intent of the meeting was to calmly gather information from each other and discuss ways of changing things in Cincinnati and Hamilton County, of how to throw the grafters and the graft-ridden politicians out on their ears. The citizens were sincere in their purpose of restoring accountability in public office and stemming the notion of Cincinnati as a lawless and deadly place.

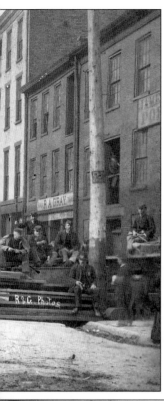

Two young laborers, Joe Palmer and William Berner, were accused of murdering Berner's boss, William Kirk. Berner was brought to trial and—although his guilt was readily established—the jury saw fit to find him only guilty of manslaughter rather than first-degree murder. One reason for the verdict was that county jails were already packed with convicted murderers; another, more valid reason in the eyes of Cincinnati citizens was that the judicial system was utterly corrupt, and that many criminals were serving easy sentences. Even the presiding judge, Stanley Matthews, thought the conviction decision was not strong enough.

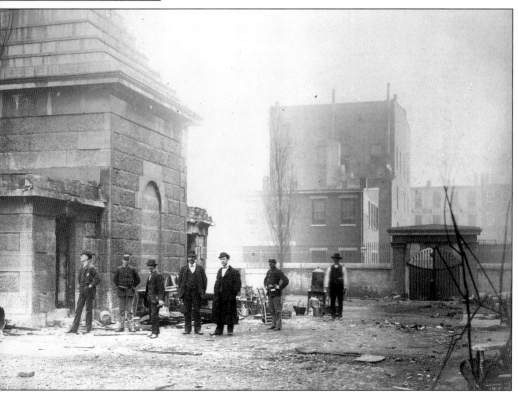

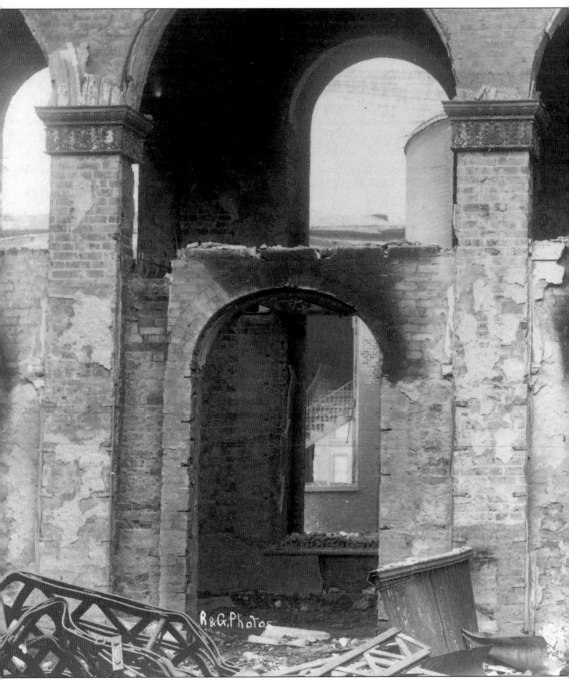

The calm atmosphere of the meeting quickly disintegrated into bitterness and complaining as citizens shouted over each other in attempts to be heard. Each had their own stories and examples of criminals running pell-mell through the streets. Someone shouted out that they should all march to the jail in protest, so the body of outraged Cincinnatians surged out of Music Hall and across town to the courthouse. What had started as a gathering of concerned residents turned into a full-fledged rioting mob. As they reached the courthouse, the crowd became more violent, hurling stones and lighting fires. Their purpose became to storm the jail,

snatch William Berner, haul him outside, and lynch him. Sheriff's deputies and police tried to stave off the rioters, and for two nights, March 28 and 29, the conflict continued. The militia was called out to help defend the city, and barriers were set up along Main Street and the canal. A Gatling gun was also set up to help maintain order. When the rioting was finally over, more than 50 people lay dead, and 300 more were wounded. The courthouse was in a fire-wrecked shambles. Since that time, the riot has become a benchmark in Cincinnati history with events and public records noted as "before the Courthouse fire" or "since the Courthouse fire."

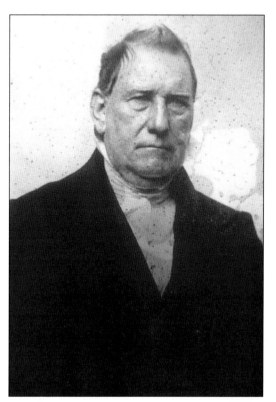

Charles McMicken was a wealthy 19th-century Cincinnati businessman and real estate speculator who brokered numerous shady deals in several states. He also owned slaves, though he provided land to free people of color, donated to the arts, and left a fortune to the city of Cincinnati to help found a university. And here was the rub: his 1858 will stipulated a school for "white boys and girls." The resulting University of Cincinnati, in 1870, successfully sued to have that provision overturned.

Appointed Rector of the University of Cincinnati in 1877, the curious Thomas Vickers also served as the director of the public library. He argued with anyone about anything, particularly religion, and was more inclined to visit saloons than he was his lecture rooms. After he was charged with 19 counts of dereliction of duty—including the hiring of drunken cronies as teachers—Vickers was dismissed in 1884, and headed out west.

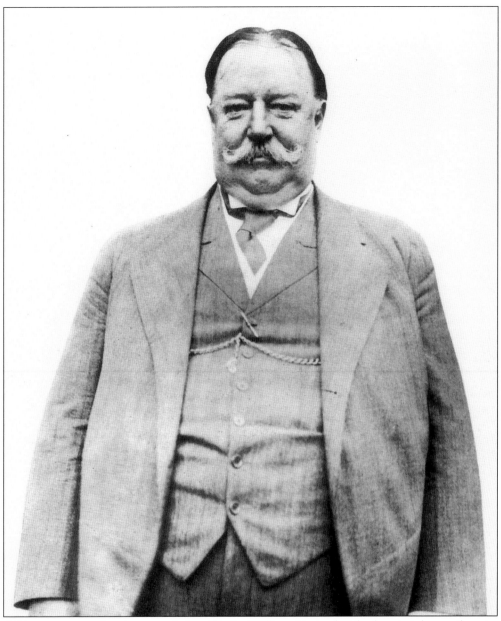

All he ever wanted to be was a judge. But for William Howard Taft, the city's largest favorite son, life proved to be more involved than that. Born in Cincinnati in 1857 of a politically prominent family, Taft graduated from Yale and the Cincinnati Law School, and then entered public life. He loved the law, and after stints as a judge, he served as solicitor general, dean of the Cincinnati College of Law, governor of the Philippines, and Secretary of War. Taft successfully ran for the presidency, but his four-year term from 1909 to 1913 was an unhappy time. Long-pushed into the political life by his wife and friends, he even commented in 1906, "Politics, when I am in it, makes me sick." A quiet, thoughtful man, Taft realized his dreams after leaving the White House by first teaching law at Yale, and then becoming chief justice of the Supreme Court, where he served from 1921 to 1930. In this picture, he is shown at a World War I fund-raiser in Cincinnati to support the Red Cross.

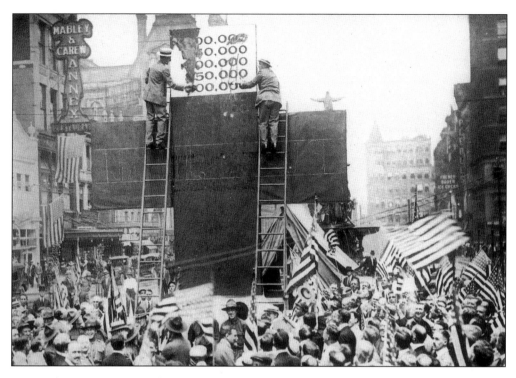

During that same 1917 World War I rally that Taft promoted, Cincinnatians came together to raise tens of thousands of dollars for the cause. These scenes downtown showed the community spirit with parades and speeches. In the top photograph, the spreading arms of the Tyler Davidson Fountain can be seen behind the tote board, and in the bottom, Red Cross nurses present an award to Reds manager Christy Mathewson for his efforts. There was a dark side to the city's war involvement, however. Anti-German hysteria arose in a city that had a very strong Germanic heritage. Shopkeepers were harassed, the teaching of German was eliminated in the schools, and streets with German names were changed to more "patriotic" ones.

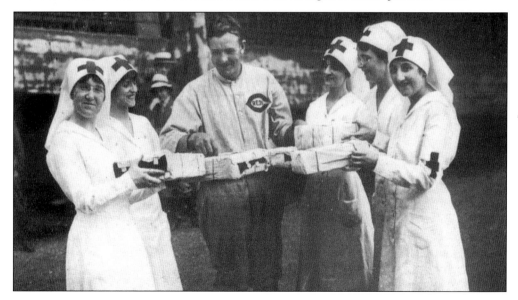

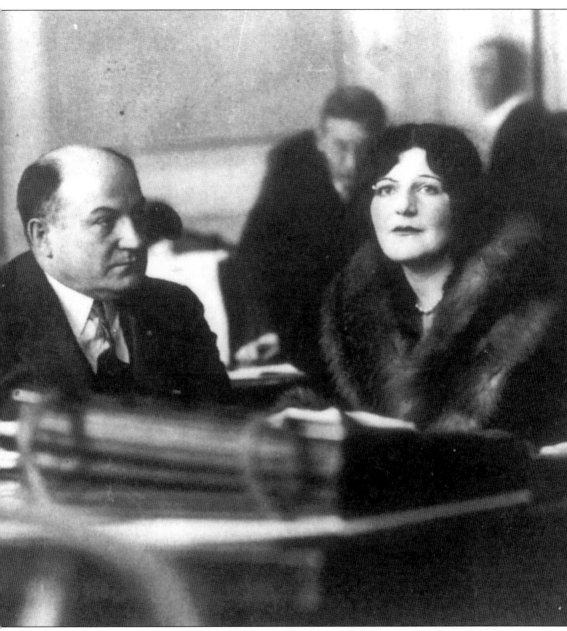

The Volstead Act represented only opportunity for George Remus. One of Prohibition's biggest bootleggers during the 1920s, Remus amassed tens of millions of dollars—much of which was variously spent on police payoffs and lavish parties—by manufacturing and distributing illegal hooch throughout the Midwest. Eventually, the G-men caught up to him, and Remus was convicted and sent to the Atlanta federal penitentiary. Meanwhile, his wife attempted to divorce him just before his release from prison. Remus managed to get the case delayed for two years, but just hours before the court hearing, he ran down his wife in Eden Park and murdered her. Shown here with his daughter at his murder trial, Remus successfully pleaded temporary insanity.

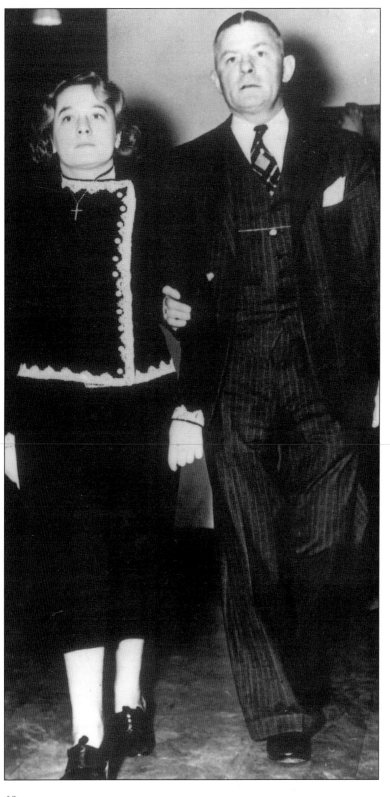

"Five victims of Anna Marie Hahn appeared in court today: four in pickling jars and one in a blue serge suit." So states an alleged lead on a news story that reported the trial of one of Cincinnati's most notorious murderers. Hahn was born in Germany in 1906 and immigrated to Cincinnati in 1929, living in the West End. Her love of horse races and gambling proved to be her fatal vice, as she killed to get the money to pay her bookies in Carthage and Hartwell. Anna Hahn would attach herself to elderly German men of moderate means, and then poison them with arsenic to get their money. Her trial was actually for the death of Jacob Wagner, one of her victims, but would-be victim George Heiss lived to testify against her. Hahn was found guilty of first-degree murder, and was executed in the electric chair in 1939. In this photo, she is led to her punishment.

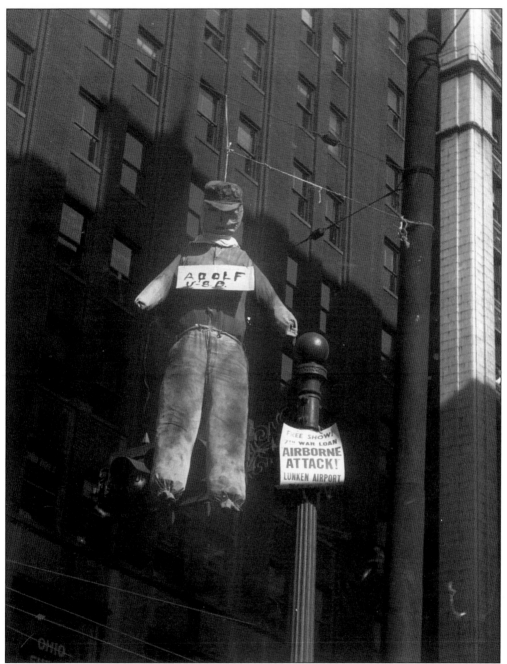

In this World War II photograph, Adolf Hitler is hanged in effigy near Fountain Square. A sign on the traffic light post promotes a civil defense show at Cincinnati's Lunken Airport. Cincinnati responded to the war effort as most cities did, with bond rallies and enlistees. University of Cincinnati students, along with other college students in the city, combed the city and suburbs to gather scrap metal, and special educational and research programs were established for military personnel. But it was also a time of revived anti-German feeling. Heads of households who were first-generation German immigrants were often rounded up with their families on short notice and sent to internment camps.

Her appearance belied the wealth she would accumulate. George Elliston (yes, George), a hard-nosed Cincinnati journalist, lived like a pauper in second-hand clothes. Though she owned some rental property and often held literary parties for her friends, she herself lived in a cold-water apartment and her normal dinner consisted of a baked potato and jello. That is, when she wasn't mooching a meal. In her newspaper investigations, she thought nothing of clambering through windows to get a first-hand look at a crime scene, and in her private life, she had an incredible passion for poetry. When she died in 1946, she bequeathed a small fortune to the University of Cincinnati to found a modern poetry collection and lecture series. The Elliston program is still a vibrant part of university life.

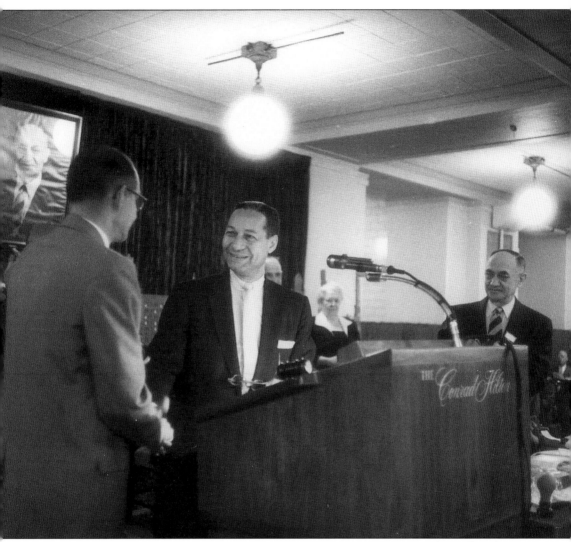

Theodore Berry was Cincinnati's first African-American mayor, serving in that office from 1972 to 1975. Born near Maysville, Kentucky, in 1905, Berry and his mother moved to Cincinnati when he was a young boy and he quickly set himself to the task of earning success. He was valedictorian at Woodward High School, earned his bachelor's and law degrees from the University of Cincinnati, and entered public service in 1932 when he was named president of the Cincinnati NAACP. Ted Berry was a hero to the city's black citizens, fighting his entire life for civil rights and fair housing, and serving as a local champion for justice. In 1942 he won his first election to city council, and in the 1960s served under President Lyndon Johnson in the Office of Economic Opportunity. When he died in 2000, at the age of 94, Berry left a legacy that bridged the racial gap in Cincinnati.

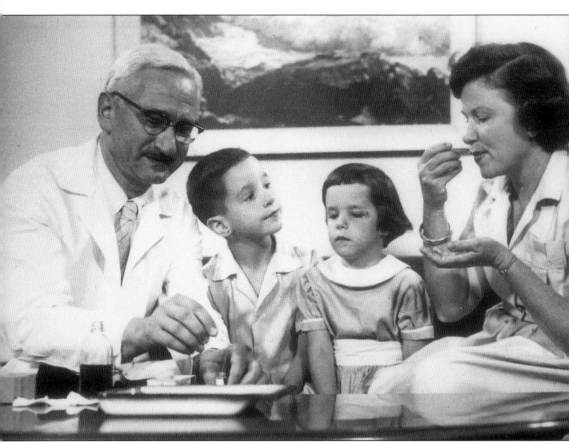

For most of the 20th century, Americans feared the onset of summer for one very big reason: it was the "season" of polio, and people over 50 can remember the days of avoiding public swimming pools and movie theaters, or darkened afternoon rooms. Polio was a disease that came in epidemic waves and could devastate a family, a neighborhood, or a community. Dr. Albert Sabin worked all his professional life in researching the transmission of infectious diseases, and labored for years and years to develop an effective polio vaccine. While conducting his research at Children's Hospital and the University of Cincinnati, Sabin developed a live, weakened oral polio vaccine, as opposed to Jonas Salk's dead virus vaccine, which was common prevention in the 1950s. Sabin's pioneering work produced a so-called "herd" immunity, and came into general use in 1961. Shown here in a publicity "test" to promote the vaccine, Sabin became a benefactor to people around the world.

Six

THE SPORTING LIFE

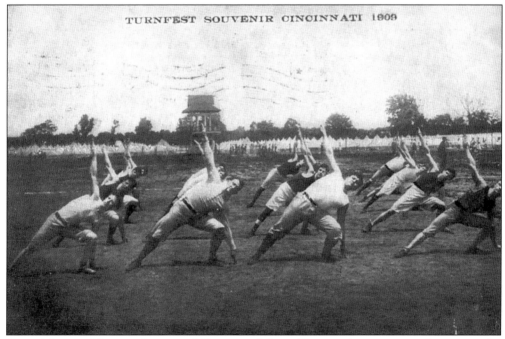

TURNFEST SOUVENIR CINCINNATI 1909

One of the notable contributions of Cincinnati's large German-American population was the notion of lifelong physical culture. Attendees at a large national Turnverein convention in 1909 were regaled with a program of sports and calisthenics.

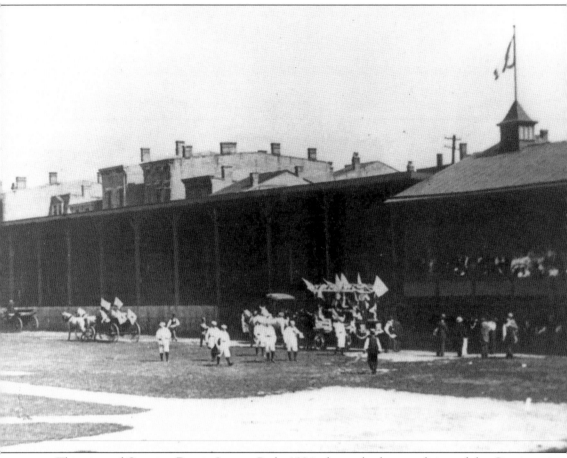

This view of Opening Day in League Park, 1894, shows the long tradition of the Cincinnati Reds in celebrating the beginning of each baseball season. Constructed in 1884 for the Reds (they were in the American Association at the time, having been kicked out of the National League for the dastardly acts of selling beer and playing on Sundays), the site was their home field until 1970, when they moved to Riverfront Stadium.

The decade of the 1890s was mainly a period of mediocrity for the Reds. Though the team was bolstered by such stalwarts as Buck Ewing, Dummy Hoy, and Bid McPhee, they rarely rose above the middle of the pack. However, the team was back in the fold of the National League—still with plenty of suds and Sunday ball.

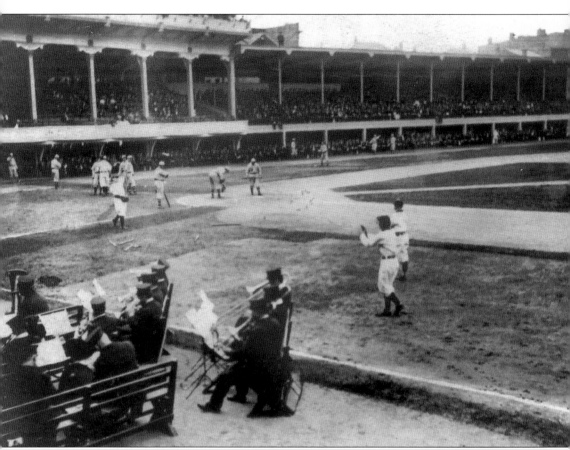

After fire destroyed much of League Park, the Reds opened a new version of the field in 1902, and dubbed it the "Palace of the Fans." A distinctive presence in the red brick neighborhood, the new ballpark followed Philadelphia's Baker Bowl in constructing its elaborate grandstand of iron and cement. The bleachers and pavilion were still made of wood. A section below the grandstands, called "Rooter's Row," was faced with fencing to protect rowdy players and fans from each other. The whole atmosphere was one of loud camaraderie, gambling, music, excitement, and cheers.

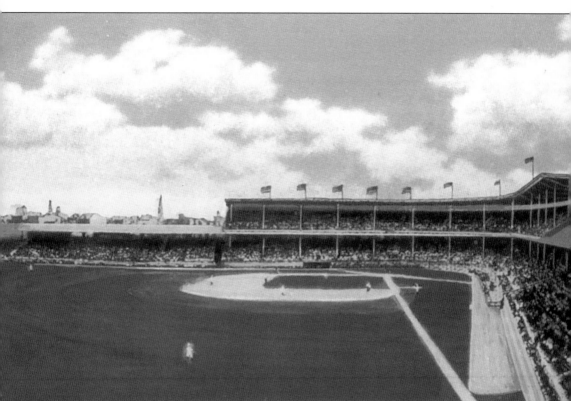

The Palace of the Fans was a little short on seating, however, and its short life ended in 1911, with its transfiguration the next year into Redland Field—one of the most spacious ballparks in baseball. Reds president, local political henchman and German-American stalwart, Garry Herrmann, commissioned the local firm of Hake & Hake to create the new park. The result was a beautiful place to play—with additional box seats for the well-heeled, of course—and one of the largest outfields in the Major Leagues. In 1934, Redland Field was renamed Crosley Field.

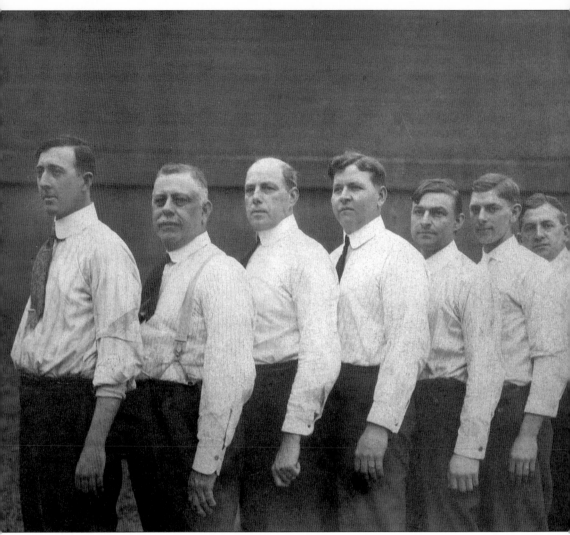

Should groundskeepers be in the Baseball Hall of Fame? If you're talking about Matty Schwab, you bet! Pictured here (third from left) with his groundskeeping staff, Schwab worked on the Reds' ballfields for 69 years, beginning in 1894. Schwab designed the drainage system for Crosley Field, as well as the famous outfield terraces. The scoreboards in both old Redland and in Crosley were his constructions, and his expertise extended to the drainage systems at other ballfields, and the design of bases. In short, Matty Schwab created the modern baseball field. His innovations were such that even a barnstorming college baseball team from Japan in the early 1900s took home his design for infield-dragging equipment.

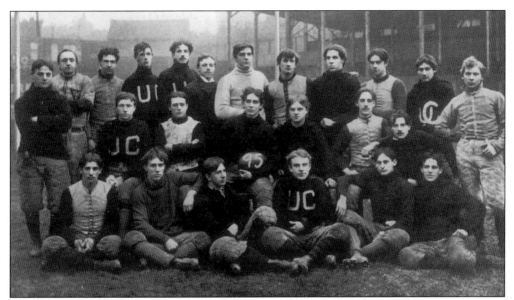

Ballparks are used for more than baseball games. They're often the venues for political rallies, parades, revivals, and other sporting events. This view is of the 1895 University of Cincinnati football team playing at League Park. The university had just moved to its new campus in Burnet Woods that year, and no other field was available. The team finished at 3-3.

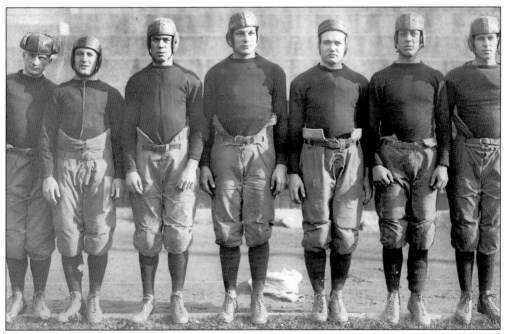

After World War I ended, colleges and universities scrambled to improve their physical education and sports programs, feeling America was weakened by the lack of competitive training. The UC backfield was at least able to play its home games on the campus' Carson Field, and compiled a 3-0-2 record in 1918, including a brutal 0-0 tie against archrival Miami University. Nineteen eighteen was notable because that football season was delayed by an influenza quarantine imposed on the school, during which practices could not be held for several weeks.

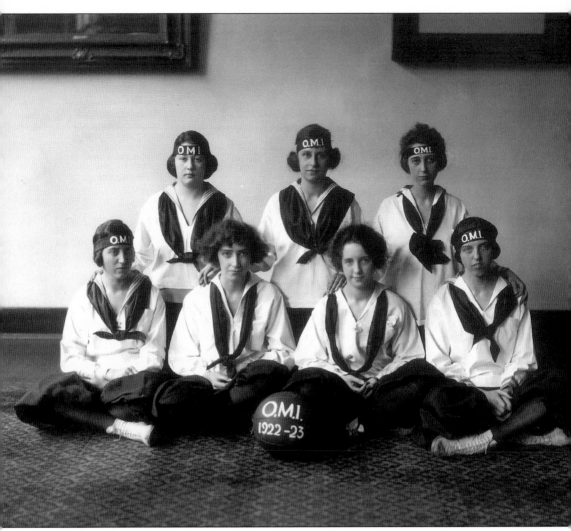

By the early 1900s, the Ohio Mechanics Institute (OMI), one of the city's oldest schools, had an active sports program. One of the most popular was basketball, or "basket ball," as it was then spelled. Women's basketball was especially popular into the 1920s, until social reformers in America thought competitive athletics were unhealthy for young women. Intercollegiate women's sports around the country would disappear at the end of the decade and wouldn't be restored until the 1970s.

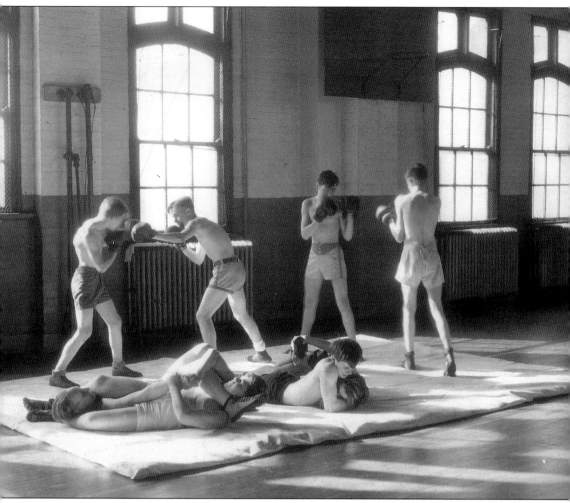

In terms of its student body, OMI was an unusual institution. In addition to college-level programs, it also provided technical education courses for high-school age students. The result was often mixed athletic teams in which some athletes were notably younger than others. This 1933 view in the Ohio Mechanics Institute gymnasium, atop the school on Walnut Street, shows the younger boys engaging in the boxing and wrestling programs.

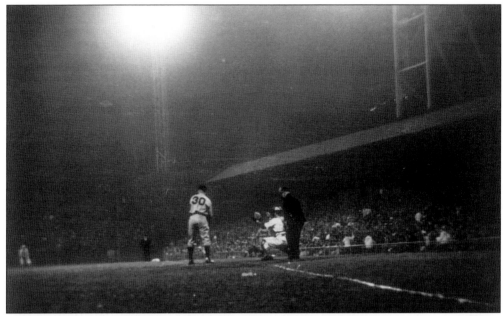

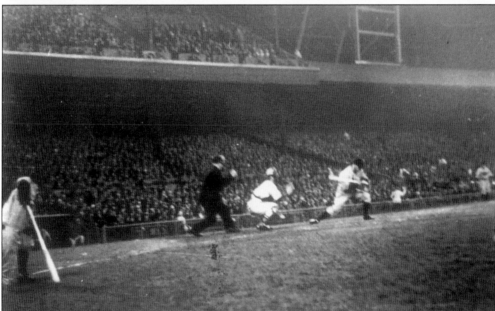

The idea of night baseball had been toyed with for many years, and some minor league and Negro League teams even used portable lighting systems to play under the stars. Night games arrived for real in the Major Leagues on May 23, 1935, when Cincinnati hosted the Philadelphia Phillies. The lighting system for Crosley Field was designed by engineer Earl Payne, who snapped these photos of the momentous event. As President Franklin Roosevelt sent a telegraph signal from the White House, Reds General Manager Larry MacPhail stood by the field and switched on the lights. Night games were the attendance-boosting brainstorm of MacPhail, one of the game's great innovators. More than 20,000 fans saw the game that night, as the Reds bested the Phils 2-1. Six additional night games for the Reds that season brought in more than 100,000 people.

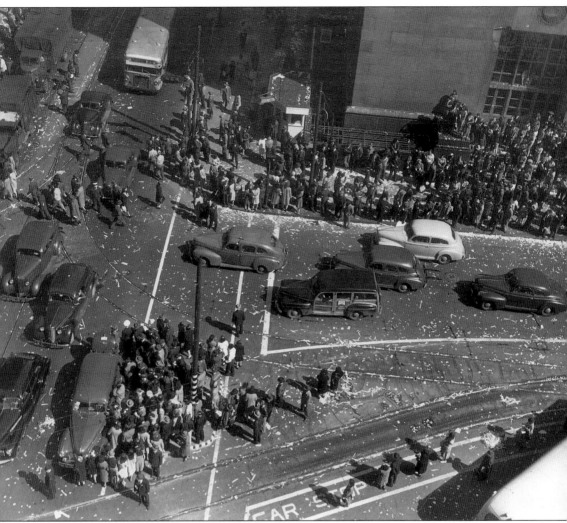

Under Manager Bill McKechnie, the Reds won 100 games in 1940 and made it to the World Series for the second year in a row. However, this time they did not fall to the American League winners, as they had to Joe Dimaggio's Yankees in 1939. They beat the Detroit Tigers four games to three to capture their first World Series title since the tarnished crown of 1919, when members of the Chicago White Sox conspired with gamblers to throw the series to the Reds. Paul Derringer had a sterling pitching performance in Game 7, as the Reds won 2-1. A downtown ticker tape celebration shown here by the Federal Building capped the championship season.

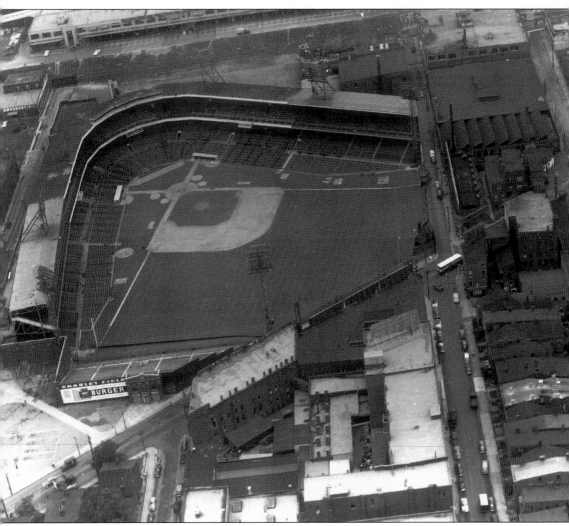

And out along Findlay and Western Avenue, Crosley Field continued to host the hometown Reds. By the late 1940s, the various ballparks on the site had survived floods and fires, but a deteriorating neighborhood would provide the end. As early as 1925, city planners had discussed a riverfront ballpark, and the talk escalated in the 1950s to relocate the Reds from an area of town where housing had been torn down and safe parking was at a minimum. In 1970, the Reds moved to Riverfront Stadium, and Crosley was demolished.

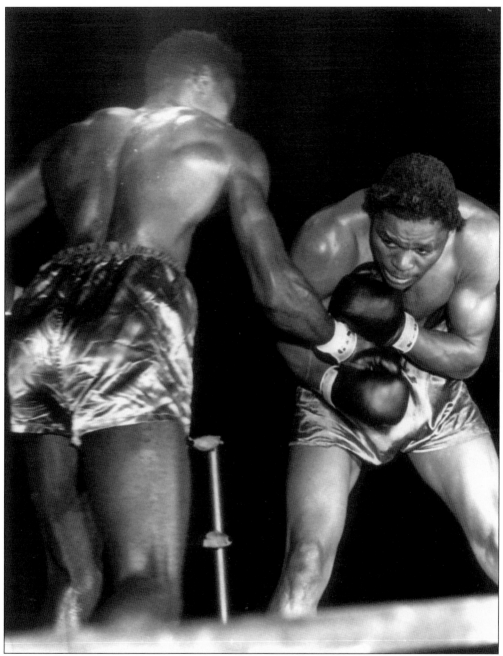

Known as the "Cincinnati Cobra," boxing champ, Ezzard Charles provided a rallying point for local African-American pride. An outstanding schoolboy and Armed Forces fighter, Charles won his first heavyweight championship in 1949 by beating Jersey Joe Walcott. A victory the following year over Joe Louis solidified his champ image in the minds of American sports fans, and he came home from the New York bout to a parade in his honor. Ezzard Charles was a devastating puncher, who, even after he lost a grueling 1954 bout to Rocky Marciano, continued to box until 1959. A street in Cincinnati's West End neighborhood is named in his honor.

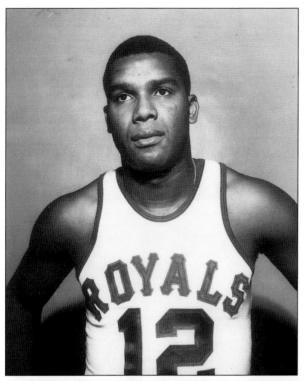

A rising star in the National Basketball Association, Cincinnati Royals player Maurice Stokes had a Hall-of-Fame career ahead of him. Then tragedy struck. In the last game of the 1958 season, the Royals were playing the Minneapolis Lakers when Stokes fell, striking his head on the court. He left the game, which the Royals won, but thought little of the injury. Three days later on a flight home following a playoff game with the Detroit Pistons, Stokes began having seizures and collapsed. Rushed to the hospital when the plane landed, he was diagnosed with post-traumatic encephalopathy. He couldn't speak or walk, and his career was over. He would be confined to a hospital for the rest of his life. But Royals teammate Jack Twyman, a future Hall-of-Famer himself, saw to it that Stokes would be helped.

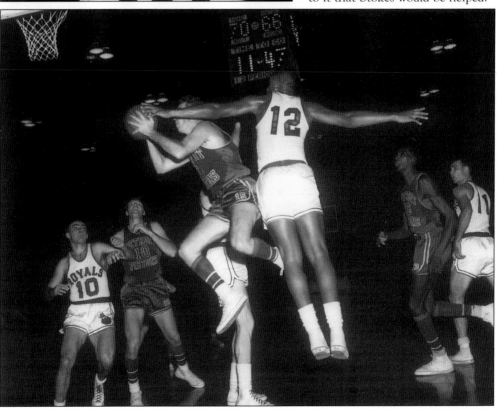

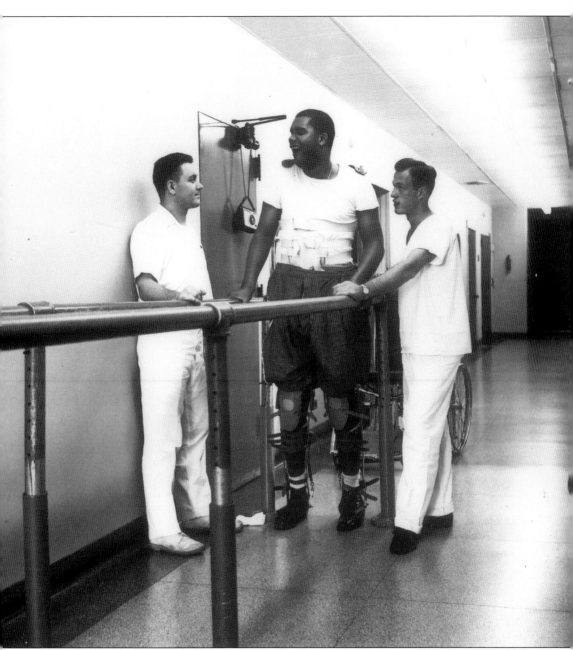

Twyman became his legal guardian and organized donations and fundraisers so Stokes could get the therapy he needed. After years of arduous and painful therapy, Stokes learned to walk with braces and regained some speech. Maurice Stokes died on April 6, 1970.

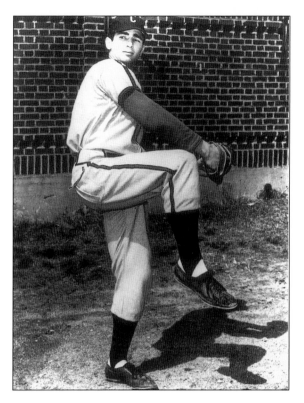

He came to the University of Cincinnati on a basketball scholarship, intent on studying architecture. But Sandy Koufax had another career awaiting him. In the spring of 1954, Koufax joined the Bearcat baseball team, astounding opposing batters with his blazing speed and unpredictable wildness. It was enough to impress baseball scouts. The Dodgers signed him to a contract that year, and Koufax became one of the greatest pitchers in baseball history.

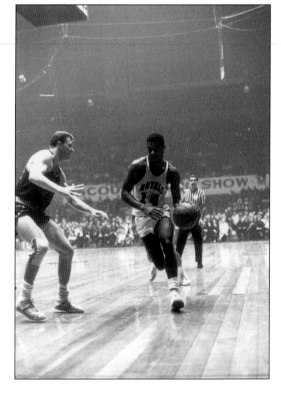

Oscar Robertson was one of the most complete basketball players in history. A three-time college player of the year at the University of Cincinnati, Robertson was one of the sports early big guards and went on to a Hall-of-Fame career in the NBA, playing for the hometown Royals and the Milwaukee Bucks. Robertson was the whole package—scoring, assists, defense, and a dogged work ethic—and had one of the keenest minds in the game.

Seven

LEISURELY TIMES

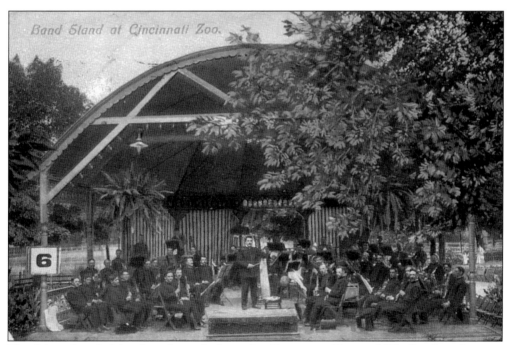

This Moorish-styled bandstand was built at the Cincinnati Zoo in 1889. Sunday afternoon concerts and summer night musical fetes were very popular, and concerts by the Cincinnati Symphony provided summer employment for the musicians. This bandstand was replaced by a reinforced concrete shell in 1911. Both facilities stood where the Gibbon Island is now located.

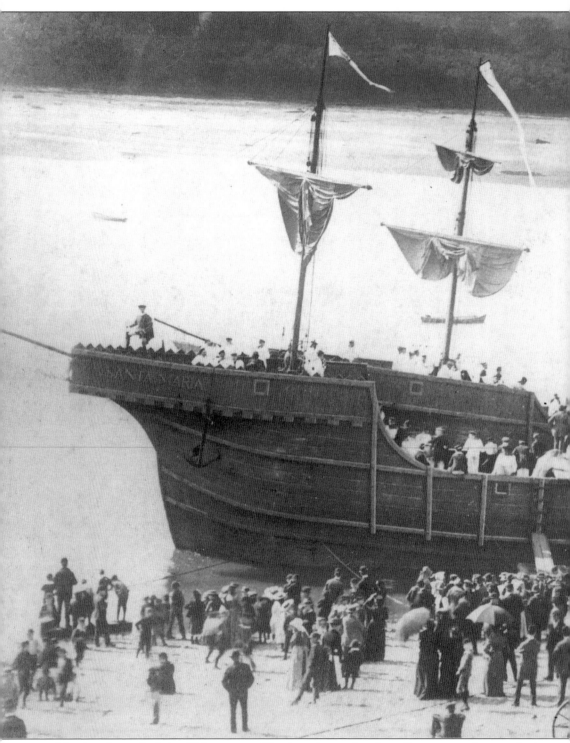

Nearing the end of the 19th century, Cincinnati was already well accustomed to producing festivals and celebrations. Along with its annual industrial and design expositions at Music Hall, one of the city's biggest parties was the 400th anniversary of Christopher Columbus'

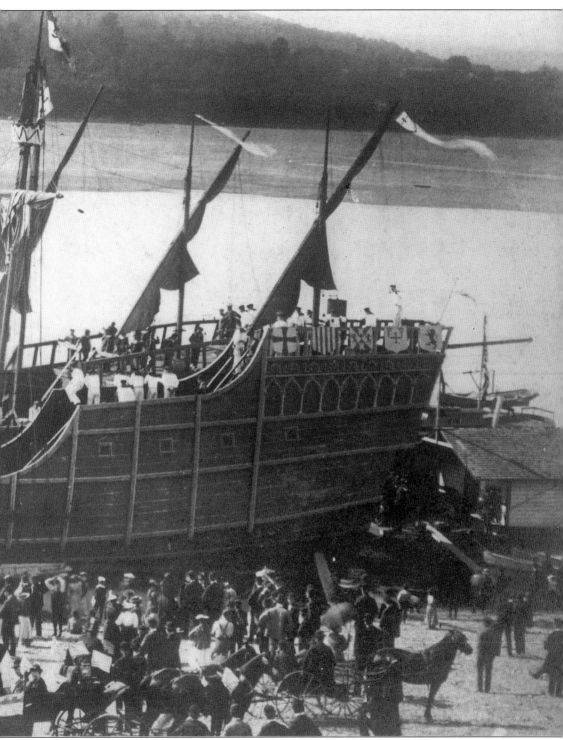

voyage to America. Replicas of the *Nina*, the *Pinta*, and the *Santa Maria* sailed down the Ohio River to the Public Landing, and citizens thronged to take part in the event. Nowadays, it is the Tall Stacks extravaganza and steamboats that draw Cincinnatians to see the riverfront.

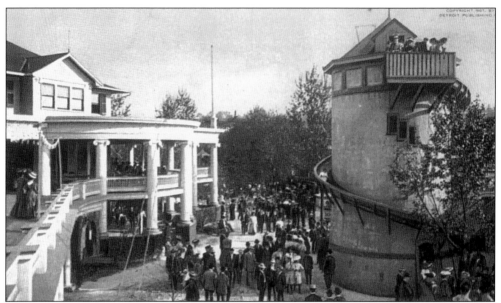

Chester Park was Cincinnati's premier amusement park in the early 1900s. Located along Spring Grove Avenue, near Mitchell Avenue on a site now partially occupied by the Cincinnati Water Works offices, it opened to the public on October 5, 1875, as a half-mile racetrack for trotting horses. It wasn't until 1895, when the track was purchased by the Cincinnati Street Railway Company, that it became the "amusement resort" pictured here. Most rides and attractions were built around the perimeter of the lake.

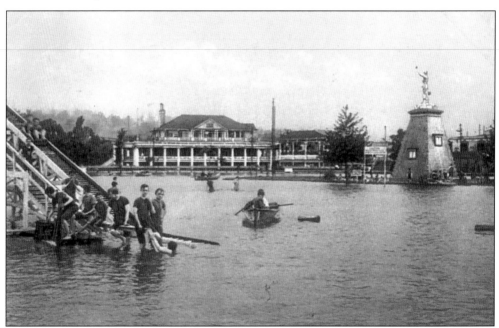

Swimming was a favorite activity at Chester Park. Shown here is the shallow portion of the lake used as a swimming area for children. Chester Park also presented concerts and vaudeville acts, and even had its own opera company. There was a picnic area for families and dancing at the park's columned clubhouse.

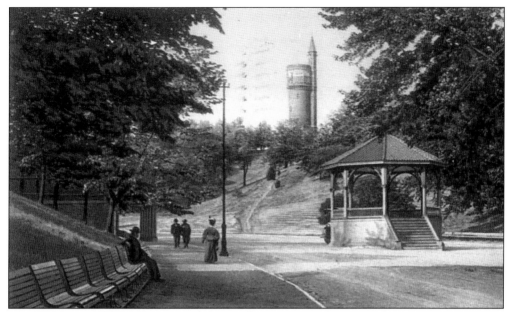

This 1906 view of Eden Park shows the small wooden bandstand in the foreground, the site of popular Sunday afternoon concerts from 1872 until it was razed in 1914. On top of the hill is the Eden Park Water Tower, built in 1894 to provide sufficient water pressure to the hilltop suburbs. A hand-operated elevator could take visitors to an observation platform. The tower's copper spire was removed for a World War II scrap metal drive.

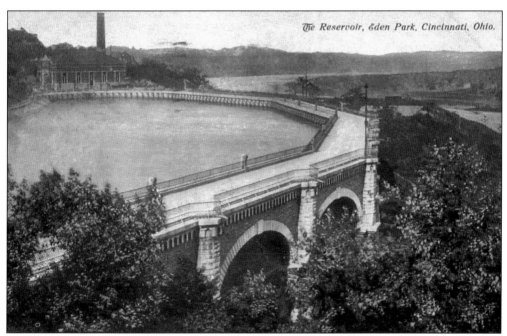

The Reservoir, Eden Park, Cincinnati, Ohio.

In the 1850s, Cincinnati Water Works officials decided that Mt. Adams was the ideal spot for a badly-needed reservoir. The purchase of the land was also the impetus for the creation of Eden Park. Built in two basins with an eight-day supply of water for the city, the reservoir was used until the early 1960s. A reflecting pool and baseball fields now sit atop the old basins.

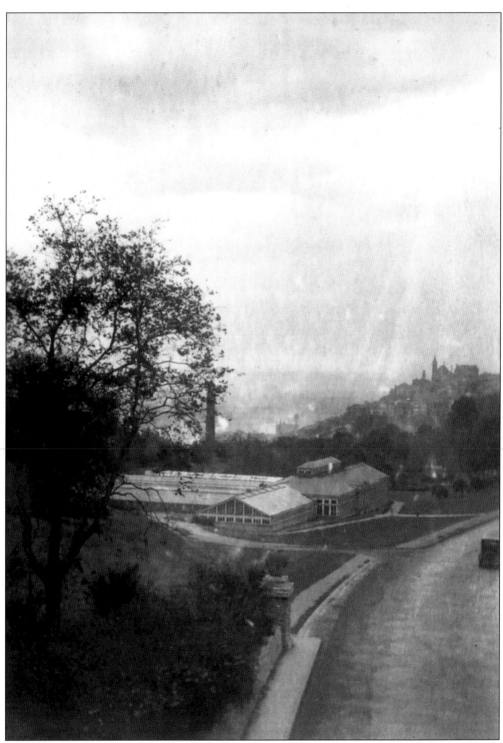

Following the 1894 and 1903 structures (shown here), built to provide plants for city parks, the Irwin M. Krohn Conservatory first opened for show purposes in 1933, with a waterfall, fern house, and display wings for seasonal exhibits. Mt. Adams can be seen in the background.

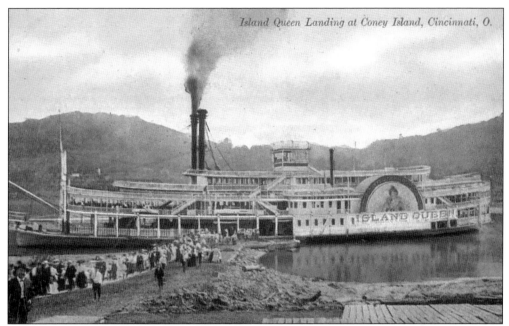

Although Coney Island could be reached by horse and buggy, the most popular and practical way to get there was by steamboat. The amusement park opened on a former picnic grounds in 1886, and during its first decade, several boats shuttled pleasure-seekers from the city's Public Landing to Coney and back. In 1896, the *Island Queen* was launched as an excursion boat, noted for its open decks, large ballroom, and a calliope.

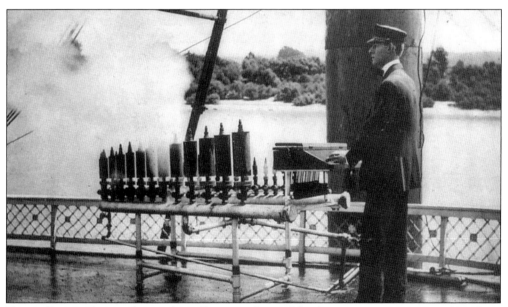

Homer Denney began playing the calliope on Coney Island excursion steamers in 1901. Over the years he wrote a number of ragtime compositions that he featured on daily trips to and from the amusement park. Denney was temporarily unemployed after the first *Island Queen* burned at the Public Landing in 1922. He retired from playing on the river after the second Island Queen exploded at Pittsburgh in 1947.

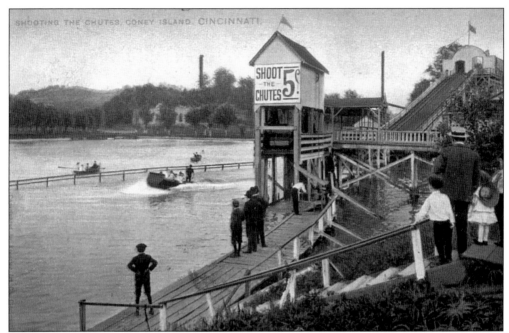

Although never actually an island, Coney felt more like one with the creation of Lake Como. Dug out of a wheat field in 1893, it provided a watery border along one side of the park while the Ohio River did the same thing on the other side. Boat rentals were the first attraction on the lake, but it wasn't until the immensely popular "Shoot the Chutes" opened that the park's focus shifted away from the picnic grounds.

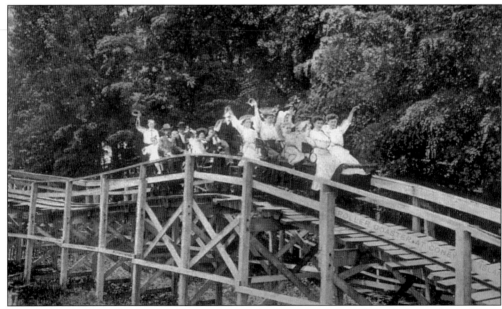

Coney Island's first roller coaster, the "Scenic Railway," appears tame by today's standards. These thrill-seekers seem to be enjoying it, however. Over the years, Coney featured many wooden roller coasters. The two most popular were the "Wildcat," built in 1926, and the "Shooting Star," built in 1947. The Star had an initial drop of 102 feet and reached speeds of 90 miles per hour.

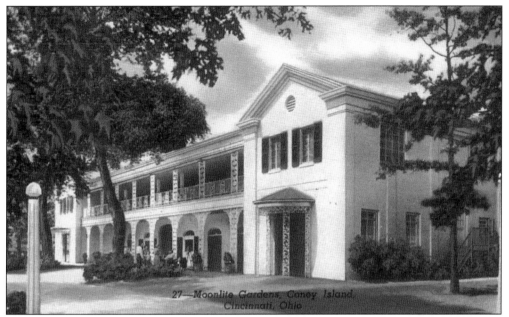

The year 1925 saw the opening of Coney's Moonlite Gardens—an open-air dance pavilion that hosted both local and nationally known bands. Local radio station WLW, with 500,000 watts, often broadcasted performances. A 1947 remodeling provided a new stage, a roof over the dance floor, and a second floor, creating the facade seen here.

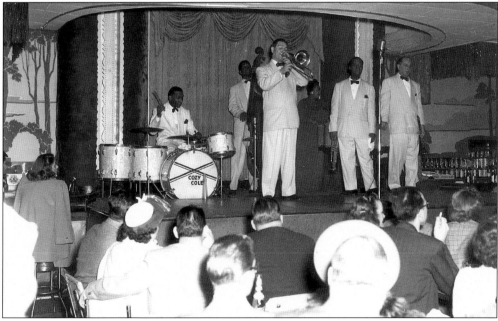

A number of big bands and singers performed in the Moonlite Gardens, including Benny Goodman, Jimmy Dorsey, and Lena Horne. Shown here is the Cozy Cole Band, featuring Louis Armstrong (second from right). Barney Rapp's band featured a local singer named Doris Kappelhoff, better known as Doris Day. In 1944, a performance by two young sisters, Rosemary and Betty Clooney, was their first show away from their hometown of Maysville, Kentucky.

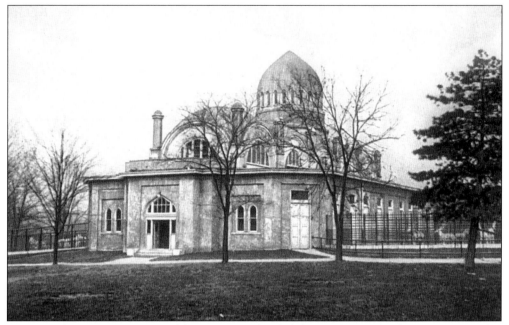

In September 1874, a group of businessmen headed by Andrew Erkenbrecher acquired a 99-year lease for a zoological park, and the Cincinnati Zoological Garden opened to an enthusiastic public in 1875. Shown here is the Herbivora Building, long known as the Elephant House, and one of the most spectacular historic zoo buildings in existence. Built of reinforced concrete, it opened in 1906.

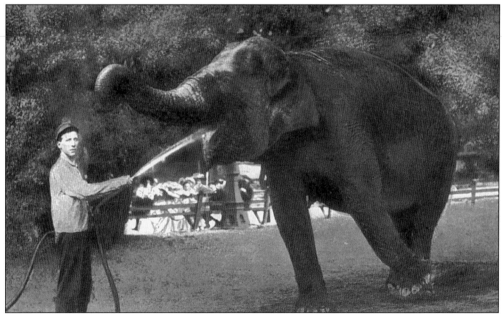

A female Asian elephant named "Hatnee" was a favorite of zoo visitors for decades. She arrived in Cincinnati on August 16, 1880, and was described as the "most gentle" elephant in the country. She frequently gave rides to zoo visitors while being led by her trainer, Ed Coyne. Here we see her taking a well-deserved break from her duties.

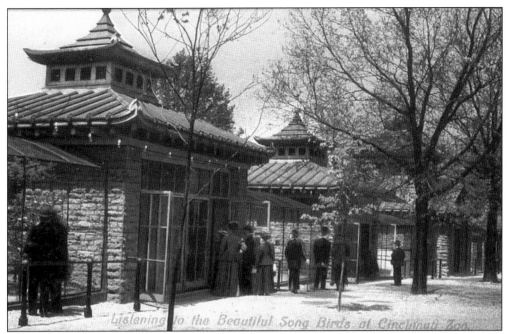

Originally there were seven of these Japanese-style aviaries, constructed at the zoo in 1875. Each had a large outdoor cage attached that allowed the birds to be seen and heard. In 1974, six of the seven were demolished, and the surviving building has been preserved as a memorial to Martha, the last known passenger pigeon, who died in one of the structures in 1914.

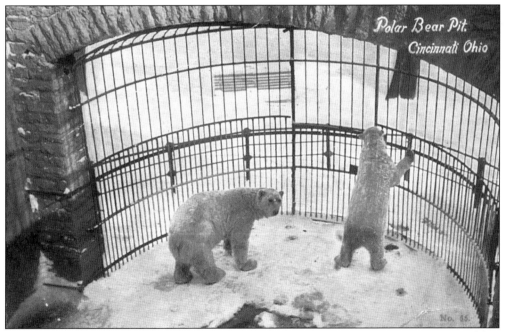

The polar bear pit was actually the middle of three connected pits, designed by James McLaughlin, and built in 1875. It was discernible by its semi-circular cage front, but unfortunately this structure no longer exists.

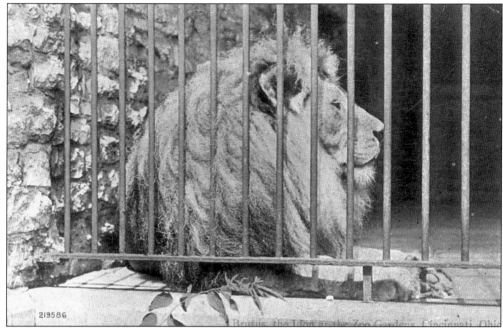

"Brutus," a magnificent male lion, was another favorite attraction of zoo visitors. This view shows Brutus in the outdoor portion of his cage at the Carnivora House, also built in 1875, but long since demolished.

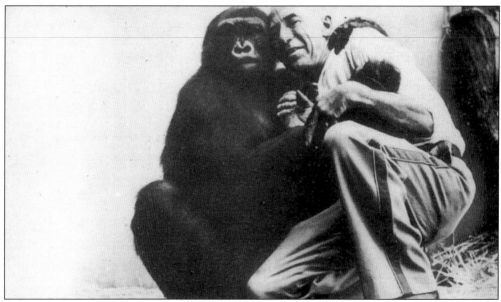

"Susie," the Zoo's first gorilla and most famous resident, was a star attraction for 16 years. Seen here embracing her trainer, William Dressman, Susie was captured in the Congo, exhibited in Europe and flown to New York aboard a zeppelin in 1929. She came to the zoo in 1931. Susie's birthday was celebrated on August 7, and every child attending her party received ice cream and cake. Susie died October 30, 1947.

Eight

MIND, BODY, AND SPIRIT

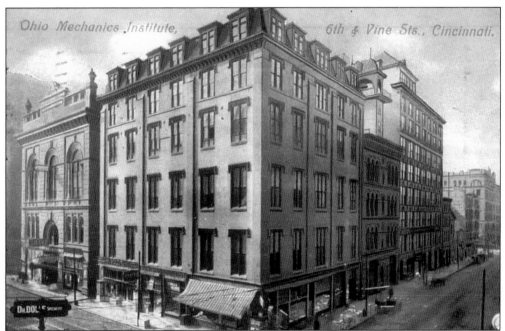

After 20 years of looking for a permanent home, the Ohio Mechanics Institute purchased a lot on the southwest corner of Sixth and Vine and constructed this building in 1848. The new structure was named for Miles Greenwood, industrialist and OMI president from 1847 to 1854, for excusing a $15,000 debt the college owed him. It was here that a young Thomas Edison read at the school's Apprentice's Library while working in Cincinnati as a telegraph operator. In 1911, OMI moved to Central Parkway to occupy a new building donated by philanthropist Mary Emery.

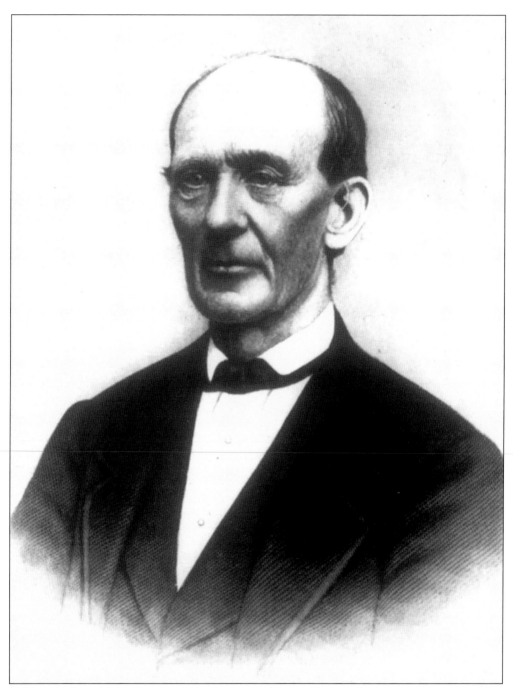

William Holmes McGuffey, he of the famous McGuffey Readers, had a roundabout teaching career that stretched from southern Ohio to Virginia. A moralist of the first order, McGuffey's memory is especially revered at Miami University, where a museum has been established. When he served as president of Cincinnati College in 1836, he began publishing his famous textbooks, more than 125 million of which were sold to the nation's schools in the 19th century. McGuffey also excelled as a professor: his lectures on moral philosophy were so popular, people who could not squeeze into his crowded classrooms would cut holes in the floor above and listen there.

Cleveland Abbe became head of the Cincinnati Observatory in 1869, and set to work on gathering weather information, a task that would eventually become the National Weather Service. Abbe also furthered the movement that would establish standard time in the United States.

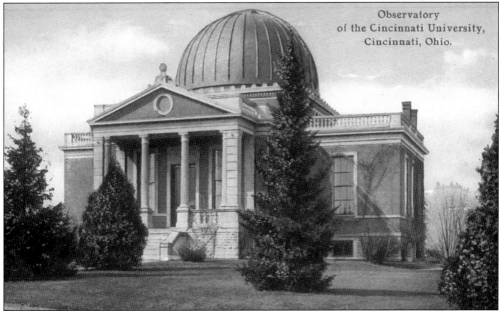

Observatory of the Cincinnati University, Cincinnati, Ohio.

The Cincinnati Observatory, in a view shown here that would be completed after Abbe's departure for Washington D.C., was founded in 1843, when John Quincy Adams came to Cincinnati and laid the cornerstone. Originally located on Mt. Ida—soon to be renamed in honor of its distinguished visitor—the observatory was the creation of Ormsby MacKnight Mitchel, who had joined the Cincinnati College. Mitchel gave wildly popular public lectures on astronomy. When light and air pollution became too heavy for the observatory's astronomers to do their work, it was relocated to Mt. Lookout in 1873, seen here.

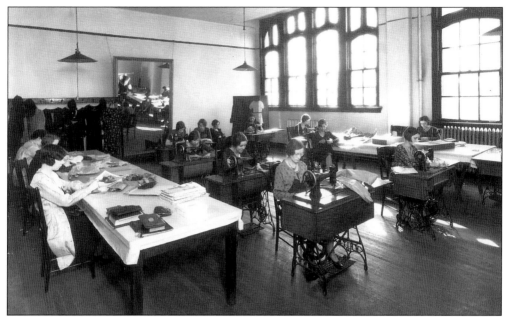

The Ohio Mechanics Institute provided a practical job-oriented training program, and provided educational opportunities for women. This photo is of a dressmaking class at the school around 1910.

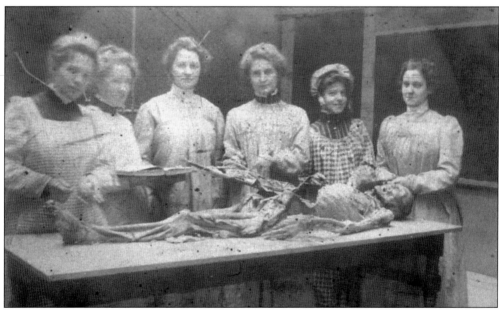

Cincinnati was home to more than a dozen medical schools in the 19th century, some of which merged with one another, others came and went as philosophies on medical education changed. The city was home to one of the first medical colleges for women in the United States. Created out of a department of the Cincinnati College of Medicine and Surgery, and known as the Women's Medical College of Cincinnati, in 1895 this school joined with another and formed the Laura Memorial Women's Medical College, which lasted until 1902. This photograph is of an anatomy class in 1895.

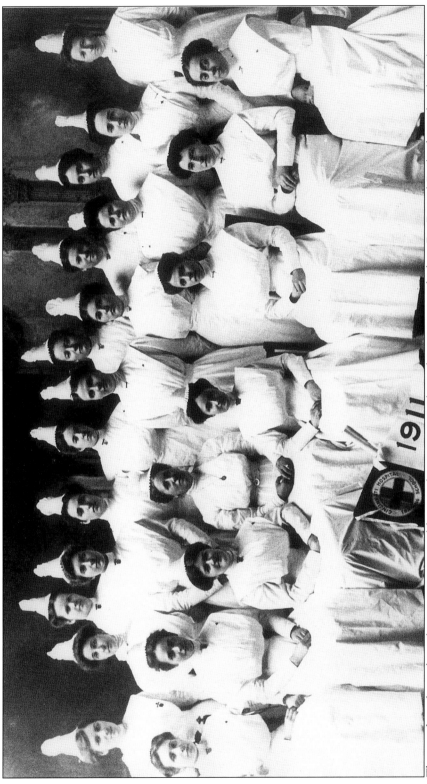

The city has always been home to a practical bent to learning, something that was created when Dr. Daniel Drake formed a clinical program at the Cincinnati Hospital and Lunatic Asylum in the 1820s, and had its full flowering in Dr. Herman Schneider's creation of the cooperative education program at the University of Cincinnati in 1906, a program now used worldwide. Practical training was also available for nurses. The Cincinnati Training School for Nurses, shown here in 1911, was founded in 1889. The school joined General Hospital in 1896, and is now the College of Nursing and Health at the University of Cincinnati.

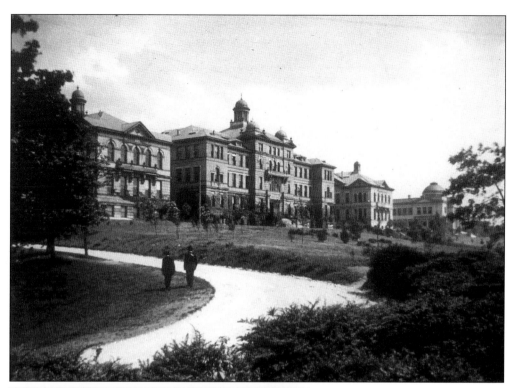

Incorporated in 1870, the University of Cincinnati traces its origins to 1819, when the Cincinnati College was formed and some of which programs UC absorbed. In this 1910 view of the university, UC has already moved to its Burnet Woods campus from the Clifton Avenue property of Charles McMicken and has already become a true urban university, bringing several of the city's independent colleges under its umbrella.

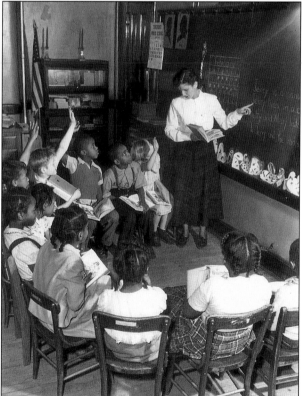

Cincinnati was one of the earliest cities to have a kinder-garten-training program, a school that grew from the 19th century into the University of Cincinnati's College of Education. Student teaching was always a requirement and gave future teachers a chance at real classroom experiences.

Jennie Davis Porter was the first African-American woman to earn a Ph.D. at the University of Cincinnati. Her 1928 dissertation was entitled "The Problem of Negro Education in Northern and Border Cities," based upon her experiences as a teacher in the Cincinnati Public Schools since 1914. Porter's dissertation argued that segregated education could be to the best advantage of African-American children. In the 1950s and 1960s, views such as hers became very controversial, but in the past decade as the idea of separate Afro-centric academies has been explored, many journalists and educators have taken another look at her work.

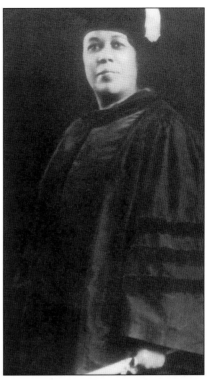

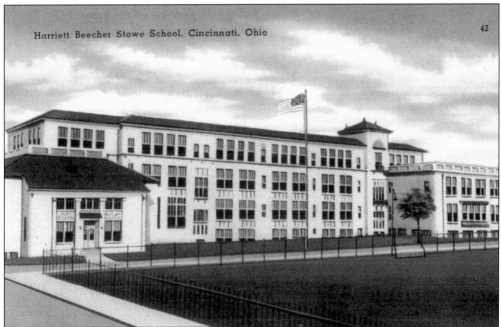

The school with which Porter was associated for most of her career was the Harriet Beecher Stowe School in the West End. As principal of the school, Porter welcomed such notable visitors as George Washington Carver and Marian Anderson to observe her teaching methods. Those methods included instilling strict conduct in the students and discipline in learning. Her motto became the school's motto: "Take what you have and make what you want."

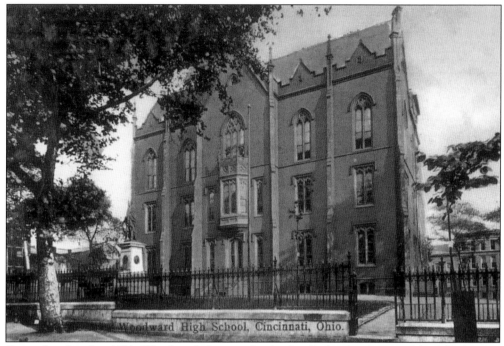

Opened in October 1831, Woodward claims to be the first high school west of the Alleghenies, and the oldest, continuously-operating free public high school in the world. Woodward joined Cincinnati's public school system in 1851. The three-story Gothic-style building pictured here was constructed in 1854-55. It was razed in 1907 to make way for the present structure, which was dedicated in 1910.

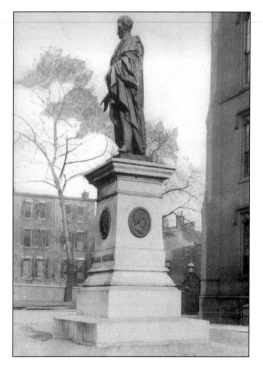

In 1860, Woodward trustees had the bodies of William Woodward and his wife re-interred in a grave opposite the building's main entrance. The bronze statue of Woodward was placed on the site in 1878. In 1953, the Woodward name and statue were transferred to a new school in Bond Hill, and the 1910 structure on the original grounds between Sycamore and Broadway in Over-the-Rhine became the School for the Creative and Performing Arts.

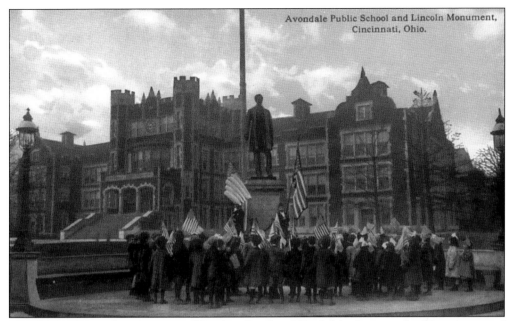

Avondale Public School and Lincoln Monument, Cincinnati, Ohio.

Located on the southwest corner of Reading Road and Rockdale Avenue, this bronze statue of Lincoln was presented to the City of Cincinnati in December 1902. The rugged figure stands on an 11-foot pedestal, at the base of which is the feminine figure of Liberty, kneeling with her head bowed and her hand uplifted. The school building in the background was the third on this site and was built in 1908.

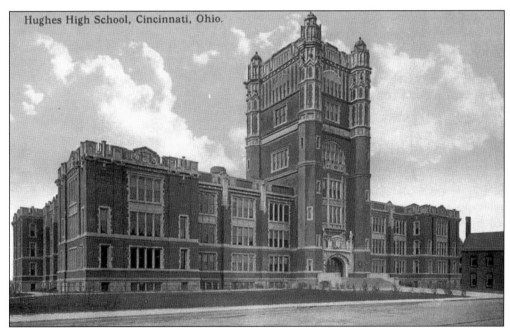

Hughes High School, Cincinnati, Ohio.

Opened in 1851, at Fifth and Mound Streets, Hughes is the second oldest high school in the Cincinnati public school system. The present building, constructed in 1910 at Clifton and Calhoun Streets, is a Norman-Gothic gargoyle-decorated structure of red brick with cream-colored terra cotta trim. The central Tudor tower is a Clifton Heights landmark.

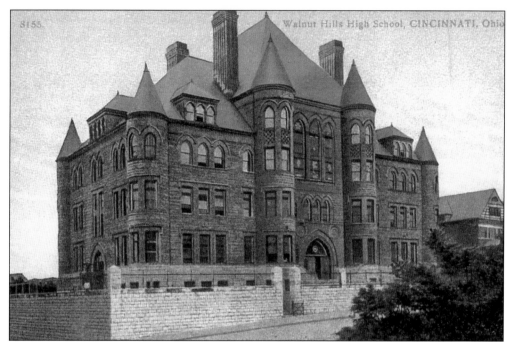

Established by the Cincinnati school board in 1895, this building stood at Burdett and Ashland Avenues. Walnut Hills High School became a college preparatory school in 1919, and over the years has boasted a number of notable alumni, from Theda Bara to Jerry Rubin. Increasing enrollment necessitated a 1931 move to its present 24-acre site overlooking Victory Parkway.

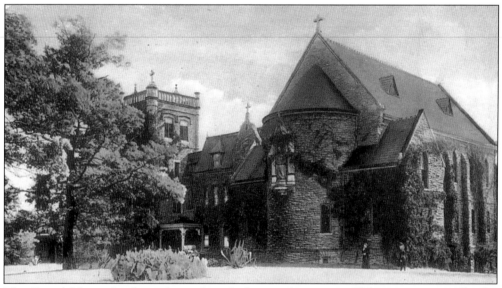

The Sacred Heart Academy, located on Lafayette Avenue in Clifton, was originally the home of William C. Neff. Built in 1868 and modeled after Kenilworth Tower in England, maintaining the home soon became more than Neff could afford. Named "The Windings," it became home to the academy in 1876. A library, chapel, classroom, and dormitory wing were added over the next two decades. The last class graduated in 1970, and the buildings have been converted to condominiums.

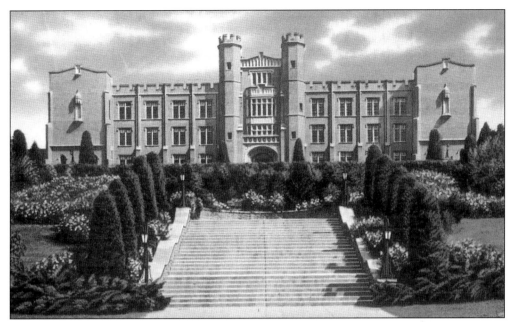

Founded as a Jesuit liberal arts college for men in 1831, Xavier University is one of the city's longest established schools. The university is coed now, and still has a focus of a strong, analytical education.

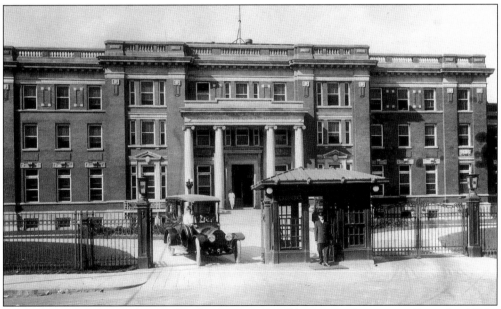

This 1916 photo shows a hospital with a long and vital history in Cincinnati. From the 1820s, the hospital has provided care for everyone in Cincinnati, rich and poor alike. As it grew, it became known as the Cincinnati Commercial Hospital and then the Cincinnati General Hospital. Originally located downtown on Twelfth Street along the canal, General Hospital moved "up the hill" before World War I, when a completely new complex was built. The new Shriner's Hospital now occupies this site, and General Hospital is now called University Hospital, located just west in a new medical complex.

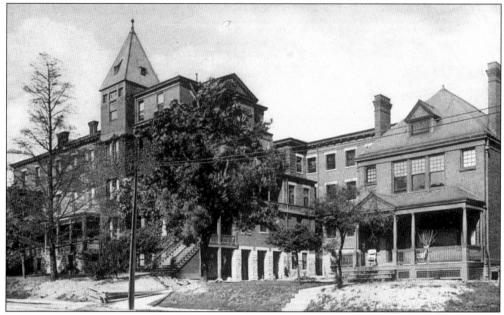

Bethesda Hospital got its start in 1898 when the German Methodist Deaconess Home Association purchased a private hospital at Reading Road and Oak Street. A nursing program was added in 1914. A 30-bed hospital for children followed in 1920, and a new main building was opened in 1926.

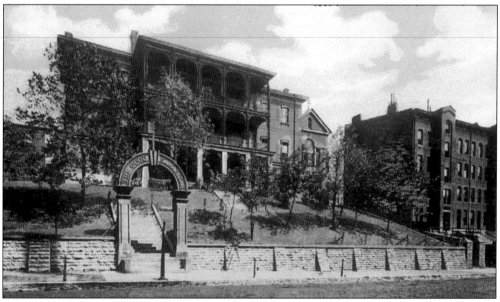

Good Samaritan Hospital's beginnings can be traced back to the 20-bed St. John's Hospital that opened in 1852 in the original Woodward school building on Broadway. The present name was adopted in 1866. During the 1870s, the hospital provided a lecture hall and clinical teaching amphitheater to students of the Ohio Medical College. The present building on Clifton Avenue was completed in 1915, with wings added in 1926 and 1945.

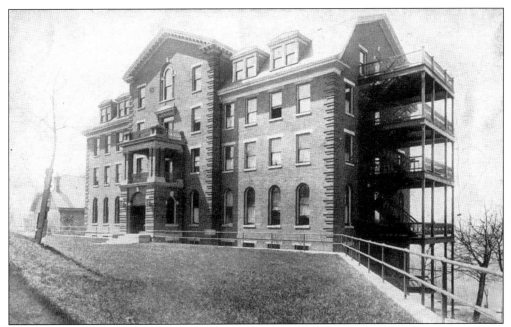

Organized as Christ's Hospital in 1889, it moved to its present location in 1893, and occupied the former building of a finishing school for girls known as the Mt. Auburn Young Ladies Institute. The School of Nursing, which necessitated the building seen here, was established in 1902. In 1904, the institution's name was officially changed to The Christ Hospital.

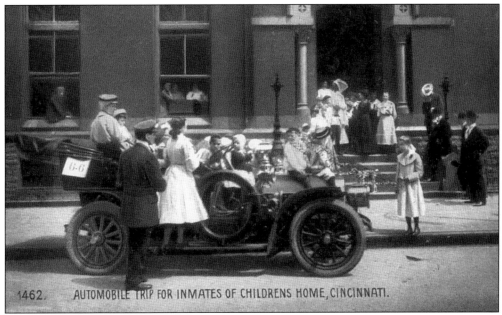

1462. AUTOMOBILE TRIP FOR INMATES OF CHILDRENS HOME, CINCINNATI.

First located in the West End, the Children's Home was founded in 1860 by Quakers who named it the Penn Mission. It offered Sunday and day-school classes to orphans and underprivileged children and, as demand for its services increased, the home moved to this site on West Ninth Street in 1878, where it remained for nearly 40 years. This 1908 view shows several children eagerly awaiting an outing, perhaps their first automobile ride.

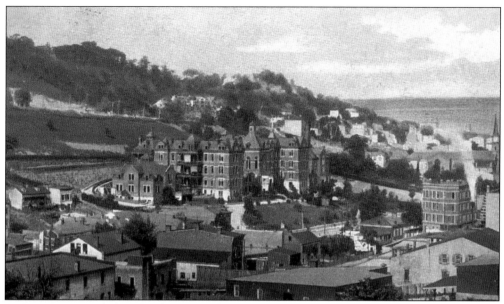

St. Francis Hospital gained early fame as the only hospital west of the Alleghenies with facilities for treating cancer patients. Established by the Sisters of the Poor of St. Francis in 1886, a $25,000 bequest of philanthropist Reuben Springer allowed construction to begin. The hospital was dedicated in December 1888, and admitted its first patient on January 2, 1889. Initially only two stories high, upper floors were added in 1893 and 1895, and the wings in 1900.

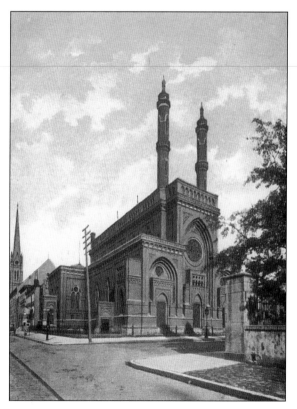

At Eighth and Plum Streets downtown is one of the finest examples of Moorish, Byzantine, and Victorian architecture in the western world. The Plum Street Temple was designed by Cincinnati architect James Keyes Wilson and built as a house of worship by the B'nai Yeshurun congregation. Rabbi Isaac Wise, the founder of Reform Judaism in America, led the local congregation from 1854 to 1900. In 1875, he founded Hebrew Union College to train reform rabbis.

The cornerstone for Cincinnati's Catholic diocesan cathedral was laid by Bishop John Purcell in 1841. St. Peter in Chains Cathedral was the second permanent cathedral in the United States (following Baltimore), and was consecrated in 1845. In 1952-53, the cathedral was renovated under the design of church architect Edward Schulte, and was rededicated as the seat of the Cincinnati archdiocese on November 3, 1957.

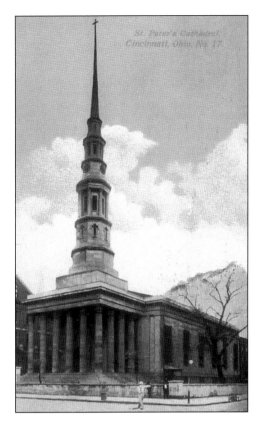

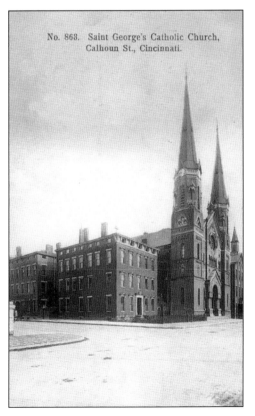

No. 863. Saint George's Catholic Church, Calhoun St., Cincinnati.

Located on Calhoun Street next to the University of Cincinnati, St. George's Church was designed by Samuel Hannaford, and built in 1874. The church primarily served the German-American community that had moved up from Over-the-Rhine to Corryville. Over the decades, St. George's was an important community presence, but with the decline in parishioners, the parish is now merged with nearby St. Monica's. The church building still stands and is an ecumenical meeting place.

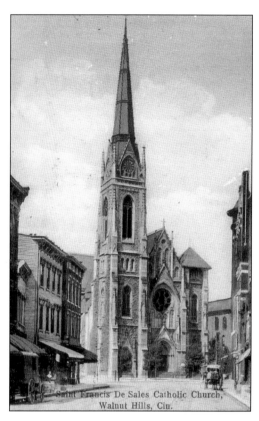

Saint Francis De Sales Catholic Church,
Walnut Hills, Cin.

St. Francis de Sales Church on Madison Road was constructed in 1879, replacing an earlier church built by the Marianist Brothers in 1850. The church features a 230-foot tower that holds "Big Joe," a bell named after its donor, Joseph Buddeke. The bell weighs 35,000 pounds, measures 7 feet high and 9 feet across. Fourteen horses were needed to haul the bell to the church. The bell rings in E-flat.

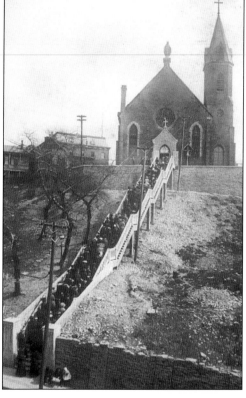

The tradition of "walking the steps" has been an Easter tradition since 1860. On Good Friday, thousands of Cincinnatians travel up the steps to Immaculate Conception Church in Mt. Adams, pausing on each stair to say a prayer. At the summit, the view of the Ohio River curving past the city is stunning.

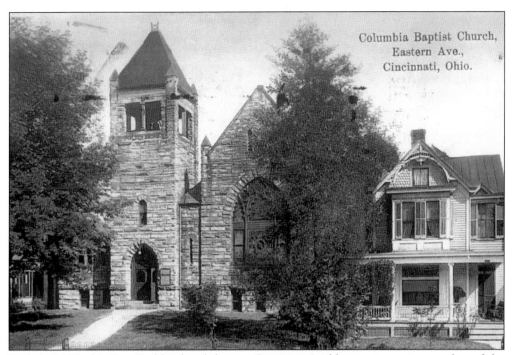

Columbia Baptist Church,
Eastern Ave.,
Cincinnati, Ohio.

Built in 1895, this East End landmark houses Cincinnati's oldest congregation: settlers of the pioneer town of Columbia founded the church in early 1790.

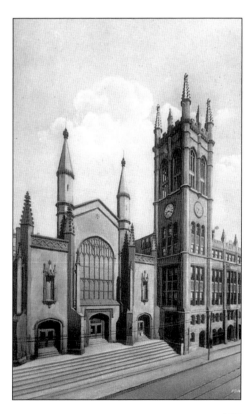

Christ Church, on Fourth Street downtown, has a history of service to the city that dates back to 1817, when the congregation first formed. The church shown here dates from 1909, when local philanthropist Mary M. Emery donated the funds for its construction. Emery's intent was that the church would contain a facility that would serve not only church members, but the poor and needy as well. The current church on the site was built in 1957. Christ Church is noted for its elaborate Boar's Head Festival, held each Christmas season.

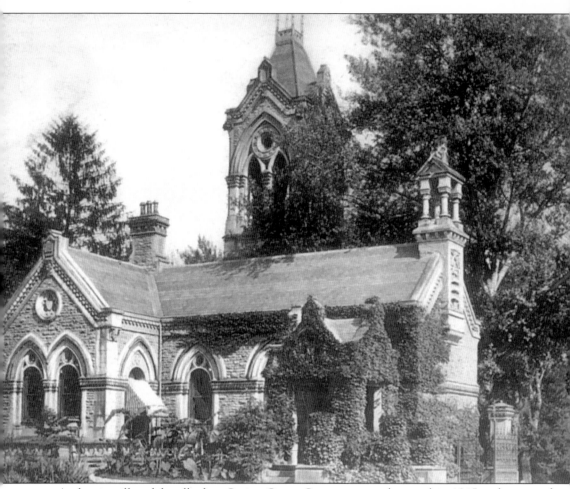

And so it will end for all of us. Spring Grove Cemetery was chartered in 1845 and is one of the largest "garden" cemeteries in the United States. Known for its beautiful grounds and landscaping, the cemetery attracts visitors as a botanical site. Elaborate monuments mark the final resting place for many of Cincinnati's notable families and citizens.

Nine

MUSIC AND THE ARTS

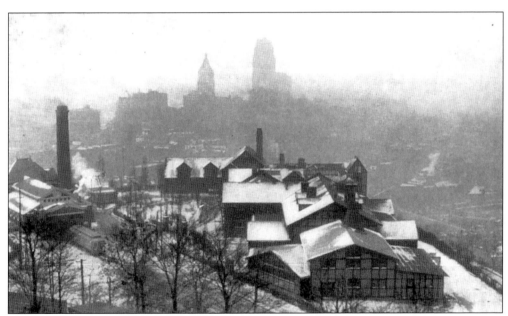

The development of Cincinnati's cultural institutions reached its peak during the last three decades of the 19th century. The May Festival, College of Music, Music Hall, the Cincinnati Art Museum, and the Cincinnati Symphony Orchestra all came into existence. The decorative arts flourished as well, with the Rookwood Pottery, founded by Maria Longworth Storer in 1880, commanding much of the spotlight. By the 1890s, Rookwood had won numerous medals for excellence at both American and international exhibitions.

A pioneer of the Cincinnati decorative arts movement, Mary Louise McLaughlin blazed the trails that others followed. After seeing French ceramics decorated under-the-glaze in 1876, it became her passion to discover the technique. Through her experiments, she developed a method of decorating the clay while still moist, and firing it before and after glazing. Rookwood "borrowed" McLaughlin's discovery and built an industry upon it.

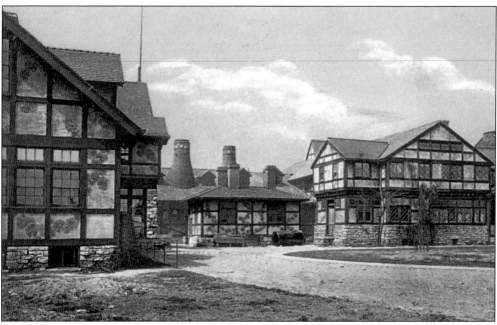

Although founded on McLaughlin's technique, Rookwood's success was based largely on artistic and technical innovation. In 1884, it became the first pottery to have a chemist on staff. That same year, a mouth atomizer was adapted at Rookwood for use in decorating ceramics. Unfortunately, the Great Depression dealt the pottery a crippling blow. After changing hands several times, it moved from Cincinnati in 1960, and closed in 1967.

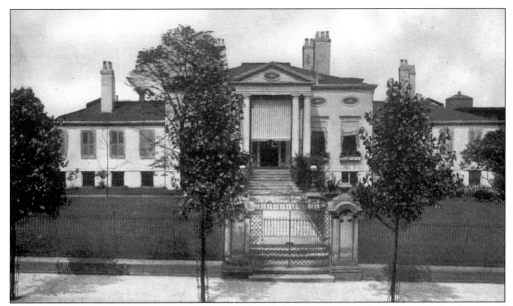

Now known as the Taft Museum, this Federal-style house at 316 Pike Street was built around 1820. Named "Belmont," it was the home of the first Nicholas Longworth from 1830 to 1871. In 1871, it was purchased by Pennsylvania iron magnate David Sinton, whose daughter Anna married a promising young Cincinnati attorney named Charles Phelps Taft, the half-brother of William Howard Taft. The Tafts traveled widely and collected art, with which they decorated their spacious home.

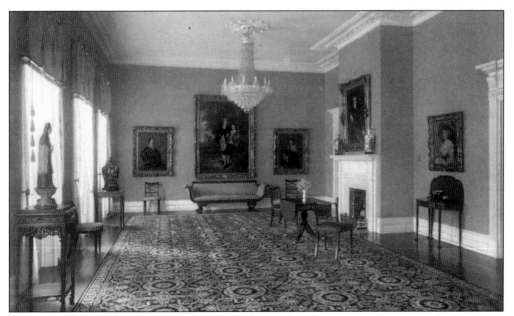

In June 1927, the Tafts announced they would donate their home, art collection, and a $1 million endowment to the city if $2.5 million could be raised from the public. All conditions were met and the Taft Museum opened in 1932. This view of the Music Room shows a sampling of the collection, which includes works by Rembrandt, Hals, Gainsborough, Sergeant, and Turner, as well as Chinese porcelains and murals by Duncanson.

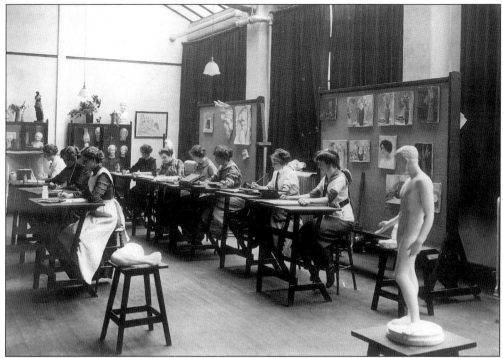

Greatly contributing to Cincinnati as a center for the decorative arts, the Ohio Mechanics Institute early on in its history offered classes and expositions on the arts. This early-20th-century view is of a drawing class at the institute.

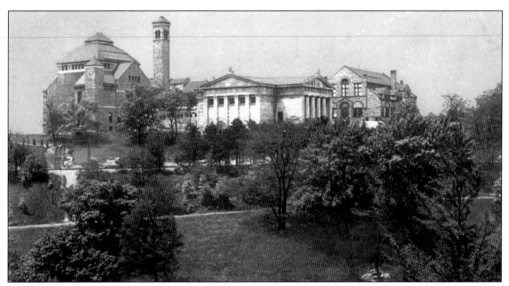

Founded in 1877, the Women's Art Museum Association's goal was to establish a permanent art institution. The group's efforts were rewarded in 1880, when Charles West offered matching funds of $150,000 for a permanent building. Renamed the Cincinnati Museum Association, the group hired architect James McLaughlin to build a museum in Eden Park. The Cincinnati Art Museum was dedicated in 1886, and its right flank, the Art Academy building, was dedicated the following year.

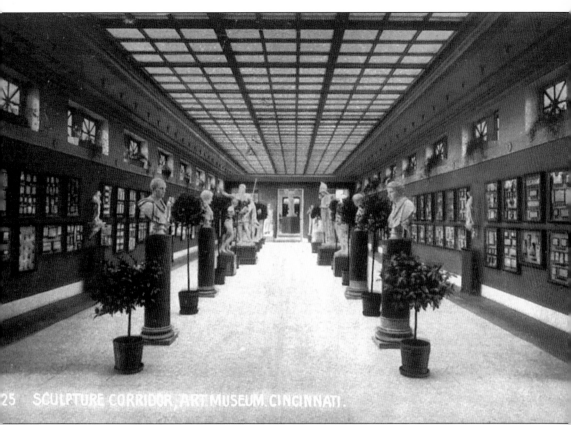

25 SCULPTURE CORRIDOR, ART MUSEUM. CINCINNATI.

Described in this postcard's caption as the "sculpture corridor," this is the part of the Schmidlapp wing that connects it to the original museum building. Today this space houses the museum's collection of Egyptian, Greek, Etruscan, and Roman art.

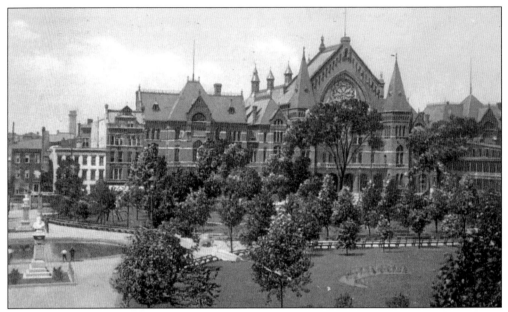

The success of the first two May Festivals inspired a fund-raising campaign for the purpose of building a permanent music center. In 1875, Reuben Springer offered to donate $125,000 if the city would provide the land and the citizenry would match his contribution. Samuel Hannaford won the design competition, and construction was completed just 14 days before the 1878 May Festival.

The concert hall featured this magnificent pipe organ, the largest in America at the time. Manufactured by Hook & Hastings of Boston, it was 60 feet high, had 6,287 pipes, and cost $32,000. The organ was surrounded by a cherry wood case made up of 121 panels, each carved by local women woodcarvers under the direction of their instructors, Benn Pitman and William and Henry Fry. The organ was dismantled and removed in 1971.

The Cincinnati College of Music was founded by benefactor Reuben Springer in 1878. It became one of the city's premier cultural institutions, and attracted faculty from throughout Europe. Traditionally, its student body was primarily male and from the Midwest and East.

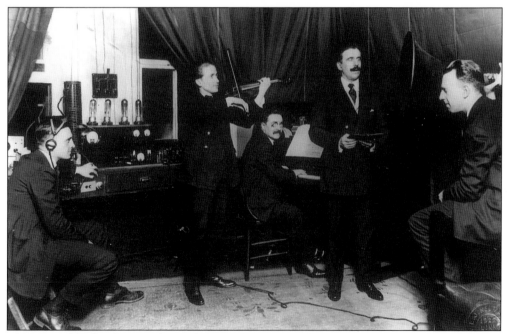

Three notable faculty members of the college were the wonderful and eccentric Gorno brothers, educated in Milan, Italy. Albino Gorno was the first to arrive, followed later by brothers Romeo and Giacinto, and Giacinto's wife, Emilia. The quartet enlivened the college for more than 50 years. Shown here in this 1922 photograph, Romeo on piano and Giacinto singing, they are part of the first radio music program on Cincinnati's WLW. Owner Powel Crosley is at the far right.

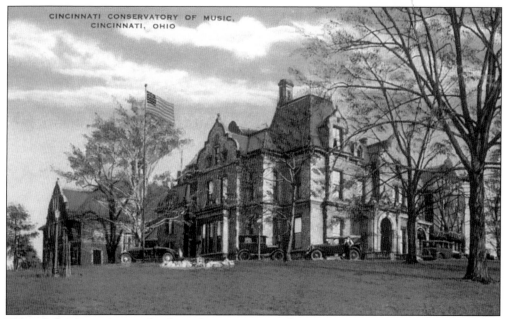

CINCINNATI CONSERVATORY OF MUSIC,
CINCINNATI, OHIO

The other major music school in Cincinnati was the Cincinnati Conservatory of Music, founded by Clara Baur in 1867. Along with the College of Music, the conservatory provided world-class education and performance in Cincinnati for nearly a century, before the two institutions merged in 1955. In 1962, the Colleg-Conservatory of Music became a college of the University of Cincinnati, and still provides the same outstanding teaching and performance.

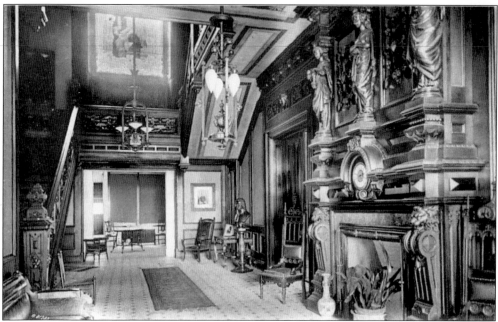

The Conservatory of Music's second and most memorable home was the old Shillito mansion, which it moved into in the early 1900s. Situated on beautiful grounds, as seen in the top image, the school's interior rooms were lavishly appointed and refined. Before the merger of the college and the conservatory, many of the latter's student body were female and from the South.

Cincinnati's Schubert Theater opened in 1921, in the old YMCA building at the northeast corner of Seventh and Walnut Streets. It featured Broadway-style productions and other forms of live entertainment. The theater closed in the early 1970s, and the building was razed in 1976.

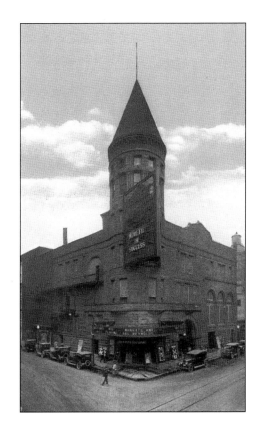

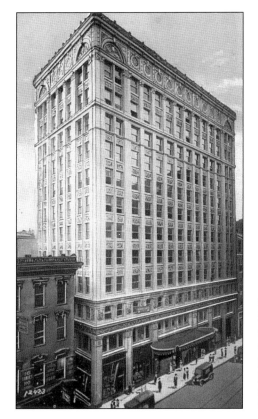

Originally the site of the Columbia Theater, 525 Walnut Street offered just about every form of entertainment imaginable over many decades of hosting theater patrons. Lillian Russell performed at the Columbia, as did magicians, jugglers, and comedians. When Keith's Theater opened, it featured vaudeville, but eventually became a first-run motion picture theater.

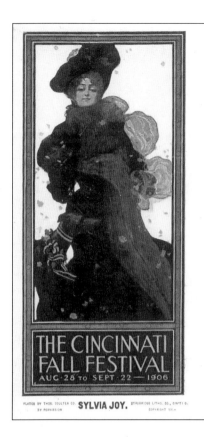

From 1900 to 1910, a series of expositions known as Fall Festivals were held in Cincinnati under the sponsorship of the Cincinnati Businessmen's Club, the Fall Festival Association, and the Chamber of Commerce. This poster, designed and printed by the famous Strobridge Lithographing Company, advertised the 1906 event.

Romeo Gorno, perhaps the most romantic of his brothers at the College of Music, taught with strong measures of verve and humor. He had the habit of meeting his young preparatory students at the foot of the stairs that led to the practice rooms, hoisting them on his back and rushing up the steps. The music library at the University of Cincinnati is named in the brothers' honor; they are just a few of the many who have brought culture, change, and meaning to life in the Queen City.